MYTHIC
BEINGS

SPIRIT ART OF THE NORTHWEST COAST
GARY WYATT

DOUGLAS & McINTYRE
VANCOUVER / TORONTO

UNIVERSITY OF WASHINGTON PRESS
SEATTLE

Douglas & McIntyre Ltd.
2323 Quebec Street, Suite 201
Vancouver, British Columbia V5T 4S7

Canadian Cataloguing in Publication Data
Wyatt, Gary R.
Mythic beings
ISBN 1-55054-639-2
1. Indian art—British Columbia—Pacific Coast 2. Art, Modern—
20th century—British Columbia—Pacific Coast. 3. Indian mythology—
British Columbia—Pacific Coast. 4. Legends—British Columbia—
Pacific Coast. I. Title.
E78.N78W915 1999 704'.039707111 C98-911073-7

Originated in Canada by Douglas & McIntyre and published in the United
States of America by the University of Washington Press,
PO Box 50096, Seattle, WA 98145-5096.

Library of Congress Cataloging-in-Publication Data
Wyatt, Gary, 1958-
Mythic beings : spirit art of the Northwest Coast / Gary Wyatt.
p. cm.
Includes bibliographical references.
ISBN 0-295-97798-1 (alk. paper)
1. Indian art—British Columbia—Pacific Coast. 2. Art, Modern—
20th century—British Columbia—Pacific Coast. 3. Indian mythology—
British Columbia—Pacific Coast. 4. Legends—British Columbia—
Pacific Coast. I. Title.
E78.B9W93 1999 99-22928
704.03'9707111—dc21 CIP

Editing by Saeko Usukawa
Design by George Vaitkunas
Printed and bound in Hong Kong by C & C Offset Printing Co. Ltd.
Printed on acid-free paper

The publisher gratefully acknowledges the support of the Canada Council
for the Arts and of the British Columbia Ministry of Tourism, Small
Business and Culture. The publisher also acknowledges the financial support
of the Government of Canada through the Book Publishing Industry
Development Program.

PREFACE

It has been almost five years since the release of the book *Spirit Faces*, which, at the time, was a rare look at the contemporary artists of the Northwest Coast and their approach to both tradition and innovation. Since that time, those artists have continued to contribute to the growth of cultural activities and to maintain a strong presence in the international art world as well. A new generation of artists, who have been given the opportunity to apprentice with or to work on major commissions with established master artists, is beginning to emerge. This has allowed them to progress quickly as artists, and their presence and dedication insures a strong foundation for the future.

Over the past decade, many developments have had a profound influence on the art form. The best of the established artists have been able to balance tradition with the need to innovate and to represent modern issues. The number and influence of female artists in Northwest Coast art has also been growing, contributing to the awareness and appreciation of traditional materials as well as reintroducing virtually lost techniques in weaving and appliqué, pushing these forms to make truly original contemporary work. New and nontraditional materials such as glass, bronze, mixed media and fabricated materials for architectural installations are drawing the attention of many Northwest Coast artists, while they continue to work in gold, silver, argillite, wood and graphics. The intention of this book is to showcase the range of scale, materials and styles that are currently being explored throughout the Northwest Coast, in a collection that serves as a window

to the future. In 1980, the Royal British Columbia Museum hosted an important exhibition titled "The Legacy: Tradition and Innovation in Northwest Coast Indian Art," which gave early recognition to many promising artists who have now earned high reputations. We hope that this collection will achieve a similar position with a new group of young artists and contrast their work with that from established artists.

I would like to acknowledge the many builders, supporters, collectors, educators and enthusiasts who deserve recognition for their support of this project and the art form as a whole over many years.

I would also like to thank the artists for offering an outstanding collection of work, for their artist statements and for checking their texts for cultural accuracy. My special thanks to Terri-Lynn Williams, Robert Davidson, Robert Joseph, Simon Dick and Joe David for checking the introduction for cultural accuracy.

I am grateful to Kenji Nagai, who took most of the photographs for this book; I have had the privilege of working with for him many years on numerous projects. And I thank Bill McLennan of the University of British Columbia Museum of Anthropology for the photograph of Lyle Wilson's *Tsimshian Cosmos* and for his long-term assistance towards my understanding of Northwest Coast art.

The staff of the Spirit Wrestler Gallery—Derek Norton, Nigel Reading and Colin Choi—have given me support throughout the preparation of this book, as well as offering critical advice, energy and counsel.

I am especially grateful to my family, Marianne, Leif, Adrianah, Ellen and Noah, for allowing me to pursue projects above and beyond the normal working day.

My sincere thanks to the following: Frank O'Neil and Rita Bieks (Emily Goes Commercial) at Vancouver International Airport; Nancy Stern; Michael Johnson, Pamela Whitworth and Fiona Taillon of the Vancouver Stock Exchange; Michael Williams of Swans Hotel in Victoria; John Livingston and Art Thompson; Doreen Jensen; the staff of the Maltwood Museum and Art Gallery at the University of Victoria; Ron Martin for writing the personal family information for the Wolf headdresses by Tsa-qwa-supp (Art Thompson); Dennis Wilson, Tom Wilford and the staff of D. W. Air in Blaine, Washington, for overseeing the shipping of artworks and lending us their space for photography.

Many museums and collectors have supported the art form at the highest level, and I am grateful to those who went a step beyond and allowed their pieces to be shipped back for photography or who allowed us to turn their homes or offices into a temporary photo studio.

Finally, my thanks to Scott McIntyre and Saeko Usukawa of Douglas and McIntyre for their dedication to publishing books on Northwest Coast art, and particularly for their vision in documenting the contemporary art form.

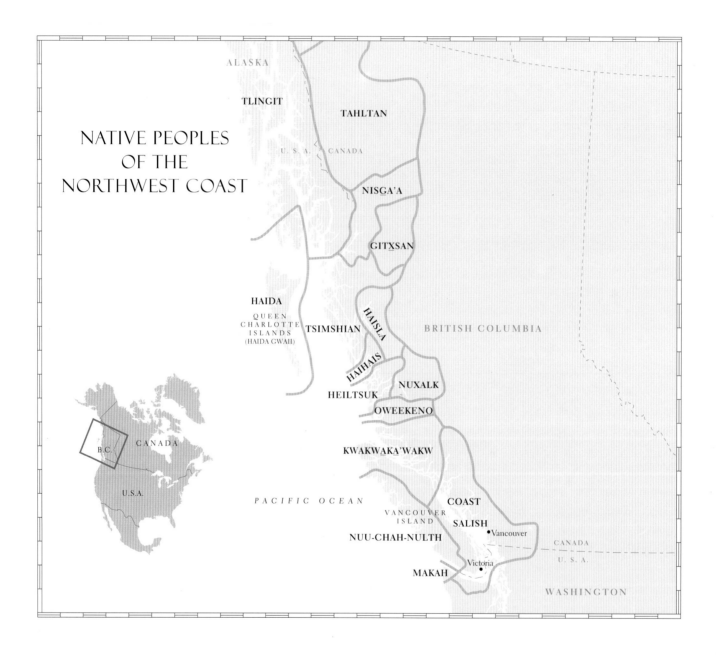

NATIVE PEOPLES
OF THE
NORTHWEST COAST

ALASKA

TLINGIT

TAHLTAN

U. S. A. CANADA

NISGA'A

GITXSAN

HAIDA

QUEEN
CHARLOTTE
ISLANDS
(HAIDA GWAII)

TSIMSHIAN

HAISLA

BRITISH COLUMBIA

HAIHAIS

NUXALK

HEILTSUK

OWEEKENO

KWAKWAKA'WAKW

COAST

SALISH

•Vancouver

VANCOUVER
ISLAND

NUU-CHAH-NULTH

CANADA

Victoria
•

CANADA

U. S. A.

MAKAH

WASHINGTON

PACIFIC OCEAN

CANADA

B.C.

U.S.A.

INTRODUCTION

The compelling power of Northwest Coast art, both historic and contemporary, has made the First Nations artists who create it known and respected throughout the world. The power of the art comes from deep roots in an ancient culture that is rich in ceremonial and aesthetic traditions. But the art was not made for the sake of art alone. For people without a written language, art served, together with oral traditions, as a means of transmitting stories, history, wisdom and property from generation to generation. Art also provides people with a tie to the land, as by depicting their histories, it is a constant reminder of the birthplaces of lineages and nations. From this rich historical base, the contemporary art—immediately recognizable and a distinct emblem of the people—continues to flourish both in its original cultural context and in the international art world.

Before the arrival of European explorers and traders on the Northwest Coast in the early eighteenth century, hundreds of Native villages dotted the islands and coastal waterways. The inhabitants lived in a world between dense rain forest and the vast Pacific Ocean. The temperate climate, together with the abundant food resources of the sea, rivers and forests, allowed the people time in which to develop a cosmology, mythology and ceremonial life that were intertwined with and expressed through their art.

The major nations on the coast are the Tlingit, Haida, Nisga'a, Gitxsan, Tsimshian, Nuxalk, Kwakwaka'wakw, Nuu-chah-nulth and Coast Salish. Each group has its own language and its own art style, as well as sharing many social and cultural structures.

Despite decades of colonization and government attempts at forced assimilation of the Native population, as well as the annihilation of entire villages due to epidemics of deadly European diseases, the people and their culture have survived. In the 1950s, there was a reawakening of interest in the art and culture, both from within and outside. This led to the founding of the Gitanmaax School of Northwest Coast Art in Hazelton, British Columbia, the first formal program dedicated to training Native artists. In the outside world, museums, commercial galleries and collectors encouraged the art and the artists with purchases, commissions and exhibitions. Today, both public institutions and private collectors who buy contemporary Northwest Coast works recognize their cultural significance and often loan them back for use in ceremonies.

MYTHIC BEINGS AND CEREMONIAL LIFE

Most Northwest Coast nations are divided into clans, and then into lineages (large extended families) that each share a common ancestor. Their life centres on the potlatch, hosted by a chief and his lineage to mark special events, and the winter ceremonies, organized each year by secret societies. One purpose of the potlatch is to publicly claim property and rights, while the winter ceremonies are devoted to retelling the exploits and activities of ancestral and mythic beings.

In Northwest Coast cosmology, the universe is shared by humans, animals (including birds and sea creatures)

and mythic beings. This universe consists of a number of realms, whose names and natures differ from nation to nation: the sky world; the undersea or water world; the mortal or land or forest world, and the spirit or ghost world. Both real and mythic creatures inhabit all the domains, except for the spirit world. In the undersea and sky worlds, beings have the external appearance of an animal, bird, sea or other creature and, much like humans, live in houses and in villages.

Many myths focus on the blurred boundaries between these worlds and the constant interaction between the inhabitants of two or more domains. These events took place long ago, at a fluid time when the universe was young and when the membrane separating the real and supernatural worlds was extremely thin and easily passed through. At different times in the past, animals or mythic beings from the sky and undersea worlds crossed over to the mortal world and, in so doing, changed the nature of the universe. Some mythic beings such as the Moon or Sun married humans, and some animals shed their skin, fur or feathers to transform into humans, becoming the founding ancestors of a lineage, clan or nation. Other ancestral beings were humans who had witnessed great events or natural catastrophes, or who had an encounter with the spirit world and received special knowledge or powers.

In one Haida creation story, Raven released some of the first humans from a clamshell in which they were living. A Kwakwaka'wakw myth of creation tells of the supernatural Halibut, who flipped himself ashore and transformed

to became the first human. (In some versions, the Halibut carried the human spirit form on its back, and the spirit transformed into the first human.) The first human then set out to build a house. But after raising the four corner posts, he discovered that he could not lift the heavy cross beams. Thunderbird had been observing the entire process and volunteered to lift the beams into place, then transformed himself into a human and became the first human's brother. The concept of transformation was not simply limited to the change of form of one thing into another. Rather, the concept of change was fundamental to the regeneration of the culture itself.

The exploits of mythic and ancestral beings were documented and passed down in songs, stories, dances, sculptures and paintings. They serve to explain relationships between nations, or between humans and the natural world. Many stories outline the delicate balance between nature and humans, or emphasize the need to respect the knowledge and power that insure this balance. The stories, songs and dances—together with the right to use depictions of ancestral and mythic beings such as the Raven or Killerwhale as crests (symbols of identity)—are all forms of property that are owned by individuals, families or clans.

The most important ceremony among Northwest Coast nations is the potlatch, through which people protect, proclaim and transfer rights and property that go back to when the world began. The word "potlatch" comes from the Chinook Jargon (a polyglot language used by traders on the coast) and means "giving," both the giving of gifts

and the giving of oneself. A potlatch is a major undertaking held to mark a significant event such as the death of a high-ranking person, or to claim a new title or name. Participants and invited guests are given gifts in payment for witnessing and publicly validating the event. The potlatch also features feasting and the performance of family-owned songs, dances and masks.

The potlatch is bound up with ceremony and art to ensure the transmission of history, knowledge and property from one generation to the next. Historical encounters with the other worlds gave rights and powers to ancestors, which were inherited by their descendants. These encounters often framed the definition of rights to territories, information that was also referred to in the art and presented to audiences for validation at a potlatch. When a family leader dies, the successor has to lay claim to territorial and other family-held rights and do so in a manner that is respectful and honourable to the lineage and that is witnessed publicly so as to be beyond dispute.

To give added weight to the proceedings, a family ancestor figure, such as Noomis, is sometimes brought into the ceremony. Kwakwaka'wakw artist Wayne Alfred says that "Noomis is as old as time itself, a survivor of the great flood." As the water rose, he retreated up the mountain until finally he had no place left to go. He was kept alive by a butterfly, who fed him until the waters receded. As the lone survivor, he carries the history of the world from the time before the flood. He enters the ceremonial hall and acknowledges the rights of the host and the structure of the ceremonies that are to be presented. In some cases he magically lights the fire. Noomis is one of several prominent ancestor figures who represent specific family history in ceremonies.

Myths, ancestors and mythic beings are made visible in every aspect of Northwest Coast life: they are carved and painted on the huge wooden buildings that housed entire families and on the monumental poles that display the owners' history and status; they are displayed on everyday objects from canoes to spoons, and they appear as an integral part of ceremonial regalia such as masks, robes and rattles. In all these and other ways, art is used to communicate, preserve and extend the culture.

Myths, ancestors and mythic beings are also given physical expression through specific ritual performances involving songs and dancers wearing masks. Mastering the intricacies of some of these ceremonies calls for years of training. Many masks have a dual role: they may simply represent crests, but when worn in the ceremonies of secret societies, they may represent mythic beings. To depict the act of transformation, artists make masks that reveal subtle changes on the top or bottom or as they are slowly rotated; others are more complex, consisting of an outer mask that splits open to reveal the mask of another being.

One of the most important ceremonial dances is the Hamatsa of the Kwakwaka'wakw and Nuxalk people, which tells of Baxwbakwalanuxwsiwe', or the Cannibal-at-the-North-End-of-the-World. His village is guarded by large cannibal birds, the Huxwhukw, the Cannibal Raven

and the Crooked-Beak, as well as the Cannibal Grizzly Bear. The dancing of the masks representing these beings from the domain of Baxwbakwalanuxwsiwe' is done by initiates who are earning responsibilities and privileges within the Hamaṫsa secret society. Before performing the dance, the initiates enter the forest for spiritual preparation; they become possessed by supernatural forces as well as loneliness, cold and starvation, and become the cannibal beings whose masks they are to dance. The initiates return to the village and are ceremonially tamed in a ritual that honours and tests the ability to overcome the powerful forces of the cannibal.

One of the beings in the Hamaṫsa, the Huxwhukw, also plays an important part in the Atłakim dance ritual, which describes the supernatural gifts of the forest. This dance tells the story of a young boy who is blamed for the death of his mother during childbirth. Rejected by his family, the boy enters the realm of the forest, where he falls asleep. He is woken by a Grouse caught in a snare that he had previously set. In return for freedom, the Grouse offers the boy a tour of the forest kingdom, where many of the treasures of the forest are revealed. The boy awakes with these treasures, which become part of his personal power, and returns to the village to reclaim his important family position. Over forty masks are used in this dance, representing both real and supernatural animals, birds and fish, as well as humans and other beings. The ownership of the set of masks is divided among several families to insure that political ties are maintained in order to present the full range of the dance.

Many of the pieces in this book illustrate the supernatural gifts that have been introduced to the mortal world through beings crossing the boundaries between the various realms.

THE SKY WORLD

Much of the mythology of the sky world is associated with ancestral beings who descended from the sky and transformed into humans to found lineages. Therefore, many crests are mythic beings from the sky world, such as Raven and Eagle. These crests are displayed on headdresses, frontlets or other pieces of ceremonial regalia to represent family connections to the sky world and heroic encounters with sky beings.

Sky beings are noted for their ability to cross boundaries between worlds. Birds dive into the ocean to take fish. They can sit in trees above the humans and animals to observe and learn their habits and rituals. They have a shared relationship with all other creatures, but their world is rarely viewed by outsiders.

The sky world is also the domain of Raven, who was present at the beginning of time, before the arrival of the first humans. Raven is a creature both real and supernatural, current and historical, as well as bird, human and many other creatures, due to the ability for transformation. Like all sky creatures, Raven can, from above, observe events as they are unfolding and choose to participate or simply witness. Driven by curiosity and mischief, the Trickster Raven is always in search of new wonders

and secrets. Raven loves to meddle in the affairs of humans, mythic beings and the natural world, creating a state of chaos still evident today.

A number of stories about Raven explain the creation or sources of many of the world's treasures. Raven stole the Sun from the chief of the sky when the entire world was in permanent darkness and gave it to light the world. According to Haisla artist Lyle Wilson, "There are many ways to portray the story of Raven and the light. Sometimes the light is the sun and other times the moon. On a deeper level, the light represents the first consciousness of human thought." Raven also stole the salmon from the Beaver and then accidentally let them slip into all the streams and rivers of the Northwest Coast.

But Raven is more than a Trickster and meddler. Raven is also associated with stories of history, wisdom and mystery, and its image on the rattles and robes owned by great chiefs is a reference to its importance and position.

The sky world also has supernatural beings, of which the most powerful is the Thunderbird. Thunderbird darkens the sky with its great shape; the clapping of its wings causes thunder, and the blinking of its wild eyes causes lightning. Watching from a heavenly perch, Thunderbird can swoop down to grasp its favourite food, a Killerwhale, in its talons.

THE MORTAL WORLD

The mortal world is home to humans and the animal kingdom, and is the source of much wealth. In the dense rain forest, the great cedar tree provides wood for houses and large dugout canoes, as well as many utilitarian and ceremonial objects. Its bark is made into clothing and rope. Plants in the forest provide food, herbal medicines and materials for basketry. Animals in the forest provide food as well as hide, bone, sinews and other raw materials.

Among the animals in the mortal world are Wolves, which are ancestors in most Northwest Coast groups, particularly the Nuu-chah-nulth, who have a Wolf ritual. There is also the Bear or Grizzly Bear, which plays a role in the myths of many groups. The Haida version of the tragic story of the Bear Mother is about a woman who is lured away by a handsome stranger who later reveals himself to be a Bear. This story is about the interrelationship of humans and animals, as well as a definition of the social order and the importance of maintaining the clan system. Both the Bear and the woman are of the Raven clan and are thus from the same lineage. When they marry and have children, they do so knowing that they have broken the law forbidding marriage between members of the same clan.

Another myth with a lesson is the sad tale of the frog. The Nisga'a version of this story is about three boys who are playing in the forest and build a fire to keep warm. A small frog tries to get past them to reach the river, but twice is tossed back by the boys. The third time, the boys throw the frog into the fire, where it burns to death. Volcano Woman realizes that the frog, who is one of her children, is missing. She tells the villagers that the boys must be punished for killing the frog, but they ignore her.

Volcano Woman then causes the nearby mountain to erupt, covering the village with lava and killing almost everyone. Nisga'a artist Norman Tait says: "To this day you can see where the lava settled for miles around. This is a reminder that all lives are precious and should be taken only for food, clothing or when absolutely necessary."

Raven often visits the forest world to plunder food from other animals or to look for adventure. Haida artist Isabel Rorick tells the story of how Raven taught people to weave spruce roots into baskets. Raven appears in human form to console a young woman who has been unjustly punished and instructs her how to prepare spruce roots to weave baskets. Raven also gives her the supernatural power to produce food in the baskets woven from it.

The forest is also a place of great supernatural power and is the realm of many supernatural creatures. One of them, in Kwakwaka'wakw mythology, is Dzunukwa, an eight-foot-tall giantess who is almost blind, clumsy and stupid. She often carries off small children, though they usually escape. Despite her negative traits, she owns many magical treasures and is therefore a high-ranking chief's crest that is among the most recognized symbols of power on the Northwest Coast.

THE UNDERSEA WORLD

The canoe was the principal means of travel and trade on the ocean waters and rivers of the Northwest Coast. The crossing of ocean straits against turbulent currents was an indication of the perils and beauty of the undersea world below. The mysterious world of the ocean was less understood and accessible than the forest.

The undersea realm has many elements similar to those found in the mortal world, including its own sky realm with birds, sun, moon and stars, as well as a spirit world with its own unique beings. There are also various stories of great sea monsters who rule the ocean.

The Kwakwaka'wakw name for the chief of the undersea world is Ḵumugwe'. He is a creature so large that his movements create ocean waves, whirlpools and tides. According to Kwakwaka'wakw artist Don Svanvik, Ḵumugwe' is often represented with a loon on his head, in reference to the story of a loon mistaking him for an island because of his great size.

The chief of the undersea lives in a great house whose planks are made of copper, and he travels in a copper canoe. Copper was a precious metal on the Northwest Coast, obtained at first in trade from other tribes and later from European traders. From this metal, artists fashioned and decorated large, shield-shaped objects called "coppers," which represent high rank and great wealth.

Relationships between all sea creatures, both real and supernatural ones, depend on their position in the domain of Ḵumugwe' and echo the relationships that exist between humans, animals and the spirit world. Among the Haida, Kwakwaka'wakw and Nuu-chah-nulth, killerwhales (or orcas) are particularly respected and honoured, in some cases as ancestral beings.

Another inhabitant of the undersea world is the people's

most important food source, the salmon. Each year, the salmon return to their home rivers along the coast to spawn and die. Along with that of other sea creatures, the life of the salmon gives humans an intimate knowledge of and respect for the undersea world. A number of myths and ceremonies are related to the salmon, particularly about respecting nature in a manner that will insure the return of this important resource each year. The salmon is also a symbol of celebration, because a large salmon run meant a secure winter ceremonial season in which there was enough food for everyone. Some stories about the salmon serve as warnings by telling about a person who violates or is disrespectful to nature and therefore must suffer the consequences.

THE SPIRIT WORLD

Kwakwaka'wakw artist Wayne Alfred describes the dance curtain that hangs across the back of the ceremonial hall, screening the place where many of the dancers prepare before coming out to perform, as the veil that separates the mortal and spirit worlds. In front of the screen is the public world, where history and mythic beings are celebrated and brought to life using masks, songs and dances. Behind the screen is the private world that is home to the many aspects of the performers' personalities and that contains the history and lives of other creatures and beings, as well as those that are still to be met in this lifetime. This veil is symbolic of the dual role of ceremonies, in which participants explore their own selves as well as exploring the collective knowledge and experience of their culture.

Many masks are visual representations of beings that exist in the spirit world or of an ancestral or contemporary experience in which a person crossed into the spirit world, then re-entered the mortal world, bringing back knowledge and treasures. These beings are made visible in the form of masks to document their physical characteristics and other attributes for people who are learning about them for the first time, as well as to be a family record for those have the right to display the crest and enjoy its associated powers.

The Nuu-chah-nulth and the Makah, the only two groups on the coast that hunted whales, have stories about the transformation from human to spirit creatures as a consequence of being lost at sea and being taken over by the spirit world. Pooq-oobs is sometimes referred to as the spirit whaler, because he is often identified with a person lost at sea while hunting a whale. The hunting team, whose priority was getting the whale, would not stop to rescue someone who had been dragged overboard or thrown from the canoe. As in the Hamatsa ritual, Pooq-oobs is associated with acquiring knowledge that comes from surviving an ordeal, and the role played by ceremonies in taming and returning such survivors to their human state.

Pooq-oobs's counterpart among the Kwakwaka'wakw is Bakwas, the wild man of the woods (not related to Dzunukwa, the wild woman of the woods). Bakwas is a three-foot-tall being who lives in the spirit world and is

often responsible for luring away the souls of lost humans by offering them food. When they eat the food, they become part of the spirit world.

Among the Haida, this creature is known as Gagiid. This is someone who almost drowned but struggled ashore, suffering the effects of hypothermia, hunger and spiritual possession. The crazed Gagiid lives by eating sea urchins and red snappers, both of which are covered with spines that stick into his face around his mouth. He grows a thick coat of hair and sometimes learns to fly. According to Haida artist Reg Davidson, "The dance of Gagiid is done in two stages. The first part is when he is in a totally wild state, and everyone present is shocked and filled with fear at seeing him. The second part is when he is captured with a cedar rope and eventually tamed and returned to his human state."

In addition to these malevolent manifestations, the spirit world is also inhabited by the souls or ghosts of the dead.

The shaman serves as an intermediary to the spirit world and is able to visit it more easily than other people. The position of shaman is gained through birth, study and experience. A powerful shaman has the ability to change form to gain power over an adversary or for protection when entering another world. The shaman may use his or her power for healing purposes or to correct the balance of nature in times of change or uncertainty. Nuu-chah-nulth artist Joe David points out that there are people with true shamanic abilities but that age, wisdom, and experience are also factors.

Like most aspects of Northwest Coast culture, the shaman displays his or her position with the ceremonial regalia created by artists. Carved headdresses, rattles, whistles, bowls, boxes and amulets are all part of the regalia. The shaman's rattle by Tsimshian artist Gerry Dudoward shows a style of rattle common to shamanic practices, and the medicine bowl by Nisga'a artist Norman Tait is an indication of the relationship between the chief, the shaman and artist. The lid of this bowl features a carved Frog, a creature often associated with the shaman because it moves freely between the separate realms of water and land, and understands the world of the deep forest.

CONTEMPORARY NORTHWEST COAST ART

Contemporary Northwest Coast art embodies a great respect for oral traditions and the carving styles of different nations, even as the artists seek to push and stretch the art form with new interpretations of traditional beings, personal visions, new ideas and new materials. Many artists not only make pieces for ceremonial use but donate their artworks and money to their communities for cultural activities, participate in ceremonial activities to deepen their understanding, and take on apprentices and assistants to help assure the future of the art.

Since many works are not simply art but objects with deep cultural meaning, artists are not always allowed to explain them in detail, especially those that are associated with songs, dances or stories owned by particular individuals,

families and clans. Some myths and masks have many layers of meaning and can be viewed from more than one perspective, a private and a public one. Other stories and masks may be shared by many families or may be known among many nations, and thus will vary in their details and interpretation.

Much of the art currently being created cannot be defined as solely contemporary or traditional. Change is necessary for any culture to survive, and the artists are a testament to the strength of their culture. As Haida artist Robert Davidson says, "We have lost so much that to simply sit and try to re-create the past would finish us—we must move forward to survive as a culture." Moreover, both the art and the culture have always been concerned with themes of transformation and regeneration, and many of the myths document a world that is ever-changing.

Today, artists are reviving old techniques as well as exploring the use of new materials such as glass, bronze and other cast metals. At the same time, they are participating and sharing in a growing interest in cultural and ceremonial activity, thereby expanding their knowledge and depth of understanding of their history and culture. The fear that the art might suffer from the introduction of contemporary ideas and materials has so far been unfounded; in fact, there is a new excitement and freshness without the loss of traditions. As Kwakwa̱ka'wakw chief Robert Joseph says, "Tradition on many levels is intrinsic to the art, conveying the very long history and spiritual elements of our people over the entire history of time, so artists will continue to respect and follow tradition because history is the foundation of the future."

In this book, new interpretations of mythic beings that play an important part in dance rituals that have been re-enacted for hundreds of years are shown beside depictions of stories and beings that represent contemporary issues and personal visions. This is a period of great change, excitement and vigour in Northwest Coast art, and it is an important time to document the established and emerging artists who are celebrating their ancient and enduring history while using their talent to secure its continuance and shape its future.

THE
SKY
WORLD

RAVEN'S EYE

SUSAN POINT: Since I started creating Salish art, a lot of effort has been directed at keeping that art form alive. It puzzles me as to why so many young artists of Coast Salish descent continue to create art in the style of other tribes of the Northwest Coast. During my earlier years, I got a lot of inspiration from my ancestral artisans, studying their pieces and re-creating them. Today, I still feel obliged to re-create their works, keeping their stories and vision alive. But I also like to cut loose, using everything that I have learned to create my own contemporary vision of past stories and the present world. There is no way that I could ever create my own contemporary vision without first having created and understood traditional images. This gives me the ability to go beyond traditional Salish art and to create a style that is my own.

The glass and yellow cedar sculpture *Raven's Eye* is just what its title is—the eye of the Raven. There are a lot of stories and legends about the Raven which are part of the large cosmic history of the Northwest Coast, and they have been around as long as the people have. The Raven has been the witness to all of my people's evolution.

The design that I used on the mirror within the Raven's eye comes from one of the oldest Salish spindle whorls*, which was made of stone. When you look into the Raven's eye, it is as though you are looking back into history (the image of the ancient stone whorl) but, at the same time, catching your own reflection and the present. The mirrored pupil of the eye is also the hole for the spindle.

In keeping with the now-and-then theme, and also with my own personal love of bending mediums, the glass rim that surrounds the Raven's eye attempts to give the impression that the whorl is emerging from it. Within the border of the glass piece, I have fossilized impressions of some of my people's earliest known implements. I have incorporated Salish eyes around the central portion of the glass to reinforce the visual theme of the piece—looking backward and looking forward into the future.

° Northwest Coast women used a spindle to hand spin and ply the wool from mountain goats into yarn for weaving. The spindle has a slender shaft that is inserted into a hole in the centre of a disk-shaped piece called a whorl. Traditionally, these spindle whorls were elaborately carved, especially by the Coast Salish.

Raven's Eye
Susan Point
Coast Salish
yellow cedar, carved and kiln-cast glass, mirror, paint
diameter 38 inches

THE SKY WORLD

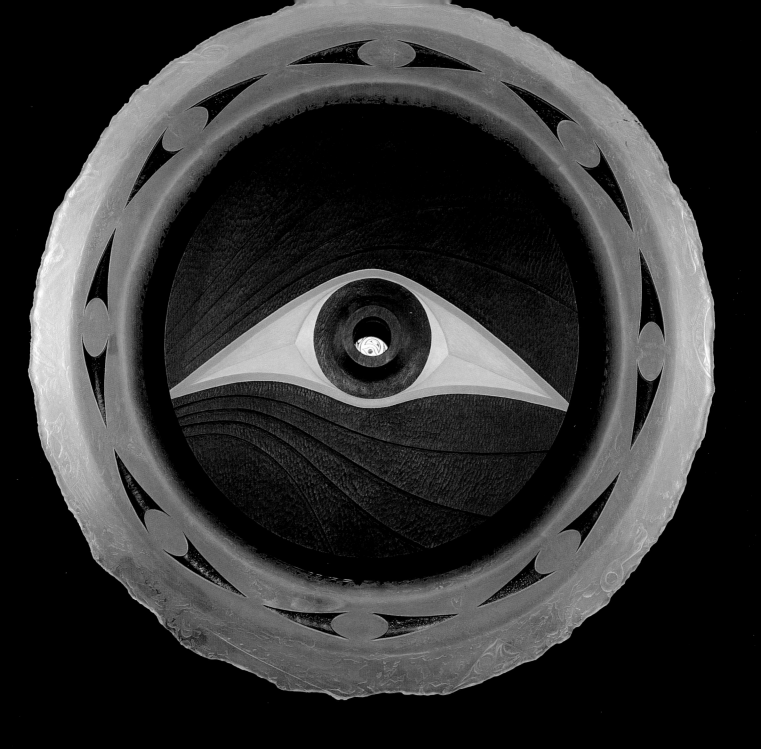

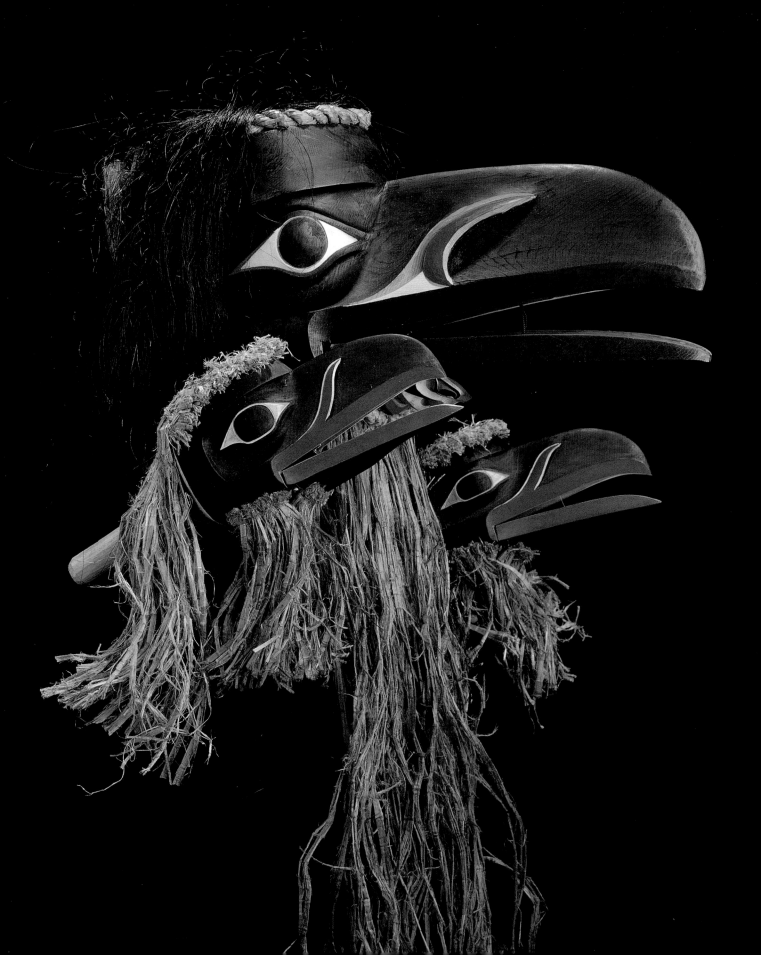

DANCE REGALIA

REG DAVIDSON: The Raven headdress and clappers are part of the regalia owned by the Rainbow Creek Dancers. In 1980-81, my brother Robert Davidson formed a dance group to maintain the few remaining traditional Haida songs, as well as to learn and create new songs and dances based on modern ideas. We began with the notion that the many layers of cultural knowledge would be revealed more by participation than by research. This has allowed us to address the idea of creating new material from a point of understanding.

Over many years, this dance group has inspired the making of masks and regalia, including several major pieces by Robert Davidson, myself and other Haida artists. I have been the principal dancer for this group since its inception, and therefore I create masks that are functional and personal. The Raven headdress and clappers have been largely used in our entrance dance to honour the Raven Clan of the Haida people.

The Rainbow Creek Dancers have performed at numerous potlatches and feasts held on the Northwest Coast. Beyond the importance of maintaining Haida culture, there has also been a growing role as cultural ambassadors all over the world.

Raven Headdress and Clappers

Reg Davidson
Haida
red cedar, horsehair, cedar bark, paint
Headdress: 22 × 14 × 10 inches
Clappers: each 13 × 7 × 4 inches

RAVEN RATTLE

FREDA DIESING: The Raven rattle is known to many of the tribal groups of the Northwest Coast. From the artist's perspective, it is a piece that is undertaken as a test of ability. There are also many historical versions using numerous creatures and arrangements, allowing room for artistic interpretation. The complex imagery has also made the Raven rattle one of the great puzzles of Northwest Coast art, leading to many theories as to its use and origins.

I believe that the Raven rattle is only a chief's rattle. It is sometimes also referred to as a shaman's rattle, but this is different from how I have seen it used and other than how I was taught by the elders who still had memories of its use. These elders were around 'Ksan during the early stages of the development of the Gitanmaax School of Northwest Coast Art there.

The chief's rattle is used to honour all the past chiefs. The most common story of the rattle is that it tells of the sound made by a bird coming out of the water, which is called Jaxj'aaxw in the Tsimshian language.

The Haida word for rattle is *giidàaw*. The Tsimshian word for rattle is *ha-seex*, which is the same in the Gitxsan, Coast Tsimshian and Nisga'a languages. *W'ii-ha-seex* means "an important chief's rattle." When the prefix *w'ii* is added to the word for any ceremonial object such as a headdress or blanket, it means "high" or "important," which also refers to its use by a chief.

Raven Rattle

Freda Diesing
Haida
maple, photo-tinting ink, cord
4 × 14 × 5 inches

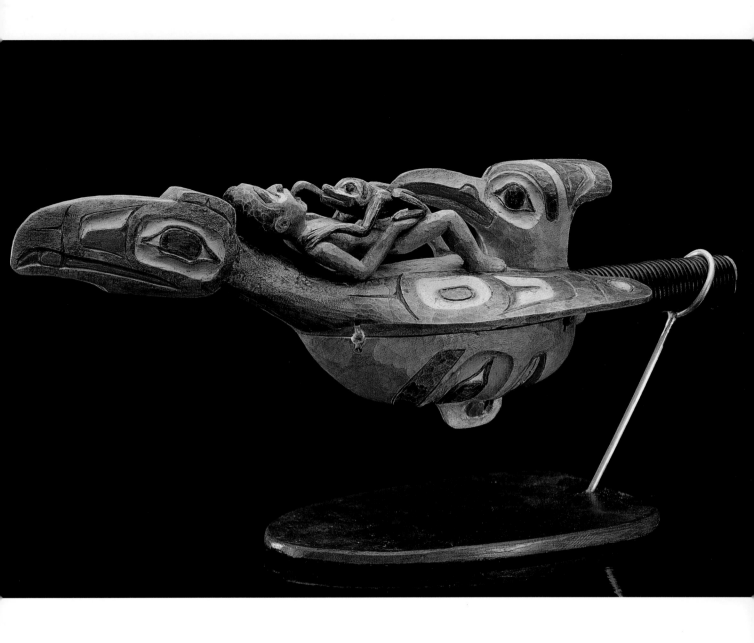

THE SKY WORLD

RAVEN AND THE GRIZZLY BEAR

VICTOR REECE: This story took place at Prince Rupert Harbour, which is now referred to as Hays Creek. Raven meets a grizzly bear who has just caught a salmon. Raven quickly mentions that the bear must be tired of eating raw fish and that he should try cooking the salmon. Raven explains the cooking process and the unique taste of cooked fish—but also says that it will take time. The bear is reluctant at first but eventually gives in to the Raven's enthusiasm.

The Raven uses the pit method of cooking—lining a pit with hot rocks and a layer of kelp. The salmon is wrapped in skunk cabbage leaves. The Raven suggests that the bear take a nap because the cooking process will take some time. After the fish is put into the pit and covered with dirt, the bear feels comfortable about having a short nap, even though he is suspicious of Raven. While the bear is sleeping, Raven replaces the salmon with hot rocks, which he wraps in the skunk cabbage leaves.

Raven wakes the bear and announces that his meal is ready. Raven digs into the pit and pulls out the skunk leaf package. He instructs the bear to eat the package whole. The bear swallows the leaf-wrapped package, and several moments later the heat of the rocks explodes inside the bear. As he falls over in pain, he watches the Raven take flight with the salmon in his beak.

Tzkzek—Raven or Tkemsim

Victor Reece
Tsimshian
alder, paint
24 x 8 x 8 inches

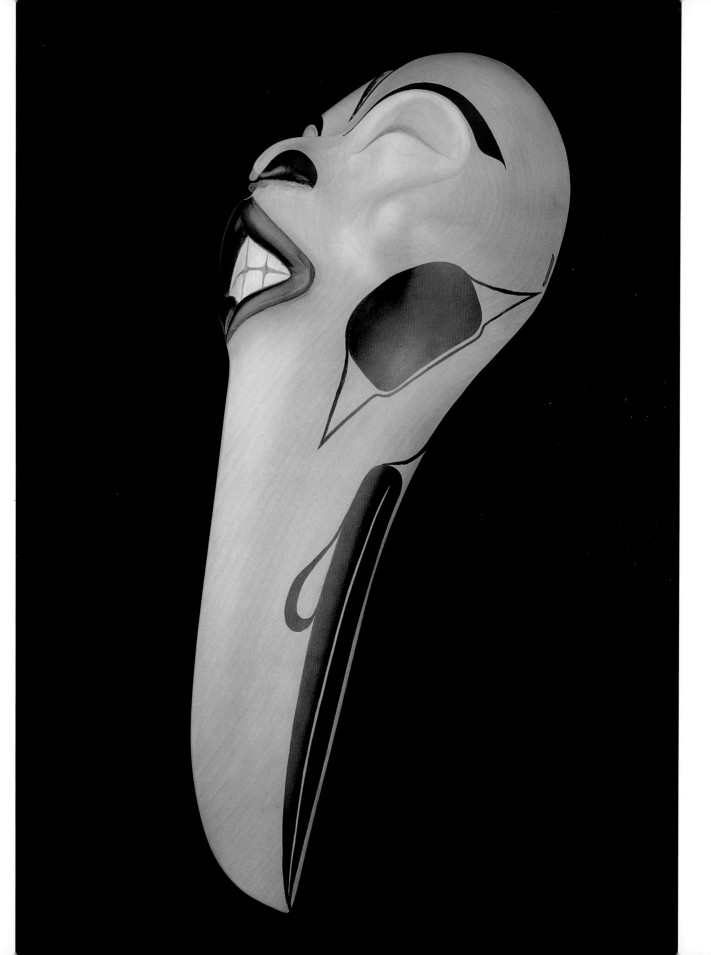

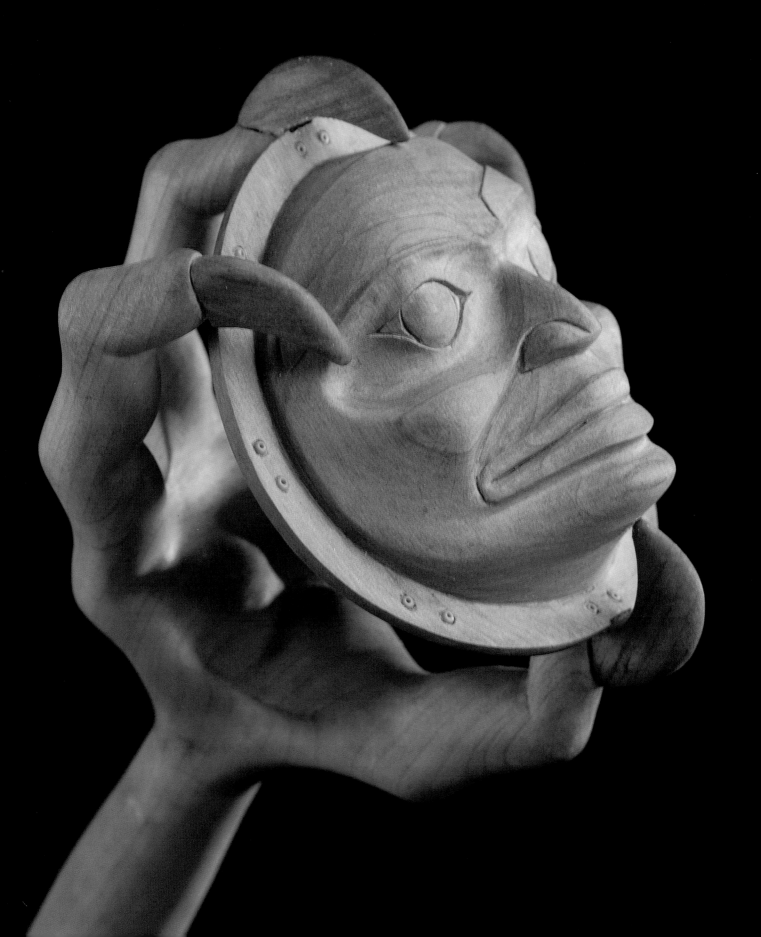

RAVEN STEALS THE MOON

NORMAN TAIT: This rattle represents the Raven letting the Moon go at the moment of the Trickster's imminent capture by the chief of the sky. Knowing that he cannot keep the Moon, Raven would rather release the Moon than return it to its owner, the chief of the sky. The Moon is grasped tightly, creating a tension between the talons of Raven unwilling to release this great treasure and the serene face of the Moon as it views the world for the first time under the majestic glow of its light.

In myth time and before the arrival of the first humans, the world was in darkness because there was no sun, moon or stars, and Raven was a white bird. Raven had heard rumours that the chief of the sky had a great treasure hidden in his longhouse in the sky. The building, however, was a fortress, and visitors were rarely welcome. Raven's usual approach of choosing a form that would be welcome at any given home would not help him on this occasion. He watched the house for several days and found that the only predictable activity was the daughter of the chief leaving the house to get a drink at a nearby stream.

Raven transformed himself into a pine needle floating down the stream and slipped himself into her cup. It soon became apparent that the young girl was pregnant. She gave birth to a young boy, who quickly proved to be a challenge in every way. The boy did, however, win the heart of his grandfather, the chief of the sky. In the centre of the chief's house was a large carved chest, and the boy often asked to see inside it, knowing that this must house the great treasure.

The chief finally relented and lifted the lid of the chest to reveal a great ball of light. The boy immediately transformed back into his Raven shape and scooped the ball of light under one wing. The chief realized what had happened and ran to block the door. Raven circled the room and saw that the only means of escape was through the smoke-hole in the roof. As he passed through the soot and smoke, he turned permanently black.

The great ball of light proved to be too heavy, and Raven was forced to descend to the ground to rest. The chief saw Raven's dilemma and took off in pursuit. Just as the chief's hands grasped the Trickster's tail feathers, Raven decided that if he could not have the light, then no one could—and he launched it into the sky.

Raven Claw and Moon Rattle

Norman Tait
Nisga'a
alder, turquoise beads
9 × 4½ × 4 inches

THE MOON

WAYNE ALFRED: Throughout my career as an artist, I have participated in ceremonies in the bighouse. I have learned about the interrelationships between families, how they are linked together, and how property and ceremonial rights are earned and passed on through these relationships.

I am fortunate to come from the Kwakwaka'wakw community of Alert Bay, which because of its isolation and dedication to tradition was able to support an uninterrupted artistic and cultural legacy throughout the past century. The art is a record of family connections, and there is a responsibility for keeping these records in the same manner as they have been since the beginning of time.

I decided to make the Moon a Tlingit one, as the Hunt family (my grandmother's) has Tlingit roots that are well documented. When you are in Kwakwaka'wakw territory and look north, you see the Moon shining over the land of the Tlingit.

The Kwakwaka'wakw use the Moon in three different contexts. One is a story about a time when everything was dry. There was no water anywhere, not on earth or the moon, except on the northern tip of Vancouver Island, where there was a river of water. The people camped there were extremely fortunate. The Moon looked down and thought how lucky they were. He yelled that he was coming down to have a drink. The people came out of their lodges to see the Moon descend in slow swooping movements. He came down closer and closer. He tried to make one final swoop, but was much too big to fit over the stream—so the Moon, still thirsty, returned to the sky.

The second is a ceremony in which the Moon appears in the form of Emos, or the Ancestor, who comes to acknowledge the family. He enters the house through the front door and moves around the room in slow swooping motions. He looks at his family to show his approval for the ceremony and then leaves by the front door.

The third is a dance, the dance of the Full Moon. It is a peace dance that is part of the Tlasala, or family dances. The chief dances, but he is teased until he runs out the door. He returns as an ancestor, entering through the front door and leaving through the back door behind the dance screen.

Tlingit Moon Mask

Wayne Alfred
Kwakwaka'wakw
alder, paint, copper, feathers
14 × 12 × 6 inches

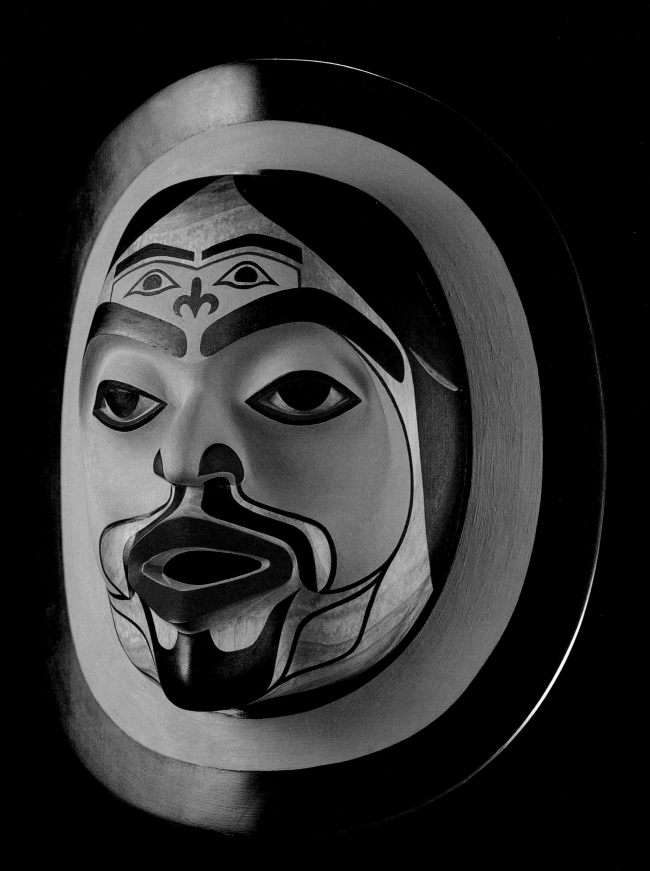

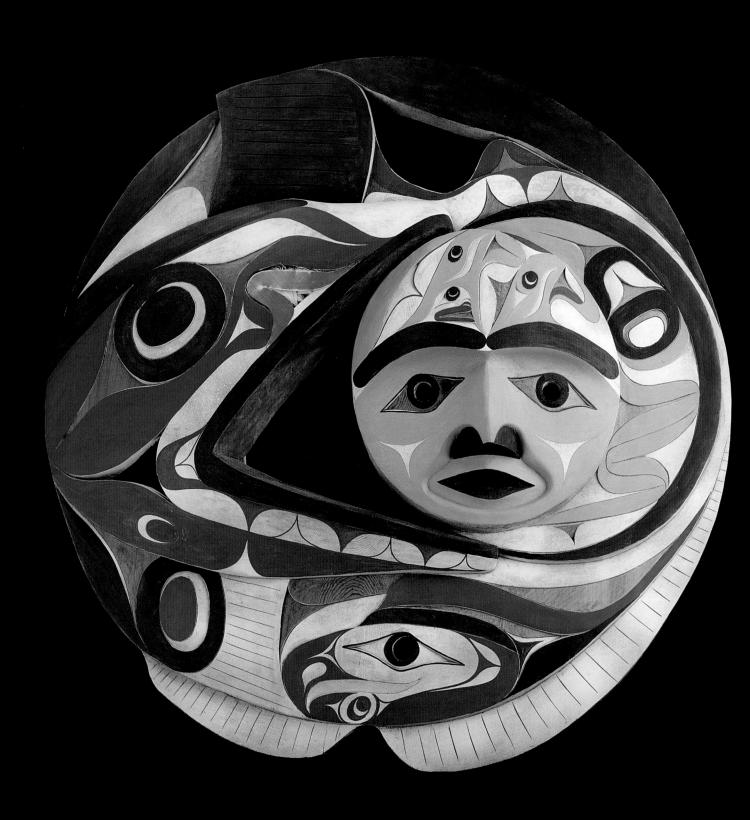

LING COD SWALLOWS THE MOON

TIM PAUL: The Nuu-chah-nulth year has thirteen moons, with an additional four moons representing the seasons. At least one elder was given the prestigious and important position of monitoring and analysing the information given by the moon. The moon told of the arrival of food sources such as salmon and the size of crops, as well as weather conditions and other environmental information. This was linked to the respectful interaction between humans and the environment, so that only what was needed was taken in times of wealth and we had the opportunity to store provisions for leaner times. Nature would often choose a course that was out of balance, and the human world would assist with the correction.

For example, every now and then, the great spirit of Ling Cod decides to swallow the moon. When this begins to happen, I was told by my grandmother Lillian Michael and Uncle Moses Smith, our people from Ehattesaht and Nuchal-litiz would line up on the beach and begin to sing to Nas, the creator, not to allow the moon to be swallowed by the spirit of Ling Cod. But if the moon was swallowed, our people would sing another song to Nas, asking the great Ling Cod to let the moon go. When the Ling Cod released the moon, our people would really begin drumming and singing to thank the creator for hearing them and to the Ling Cod for letting the moon go.

Eclipse

Tim Paul
Hesquiat (Nuu-chah-nulth)
red cedar, paint
33 × 33 × 5 inches

DECEMBER MOON

TIM PAUL: In the Nuu-chah-nulth year we have thirteen moons, one of which is the eldest sibling who arrives on December 21 or 22 to begin the new year. In addition, four seasonal moons oversee the transitions between winter, spring, summer and fall.

In this sculpture, the eldest moon is on top, sitting just above the Nuu-chah-nulth mountains that run down Vancouver Island. This is important because the mountains are our *mi-tak* (markers), which people used when they were harvesting out at sea.

The central circular figure is the December moon, Ti-asałumh, which sits on the water for four days. It announces that we are moving into a new harvesting season. We ask for a good and bountiful sea harvest for the year. The lower figure represents our most important resource, the salmon. The salmon is what our people become.

The humanoid figure on the side is Či-ha from the doorway that opens from the other dimension. He is from the world of the supernatural. We prepare ourselves by asking our *a-um-it* (ancestors) to give our people good things and allow us to prosper. They will come and give you whatever you want at *nas-win-is* (night and day cross).

The *łuma* (side posts) mark the boundary, or as far as we can go. The back of the doorway slides down and leads out to *hił-cu-is* (lands beyond the horizon).

Ta̓-šii (**Doorway**)

Tim Paul
Hesquiat (Nuu-chah-nulth)
red cedar, paint
43 × 29 × 8 inches

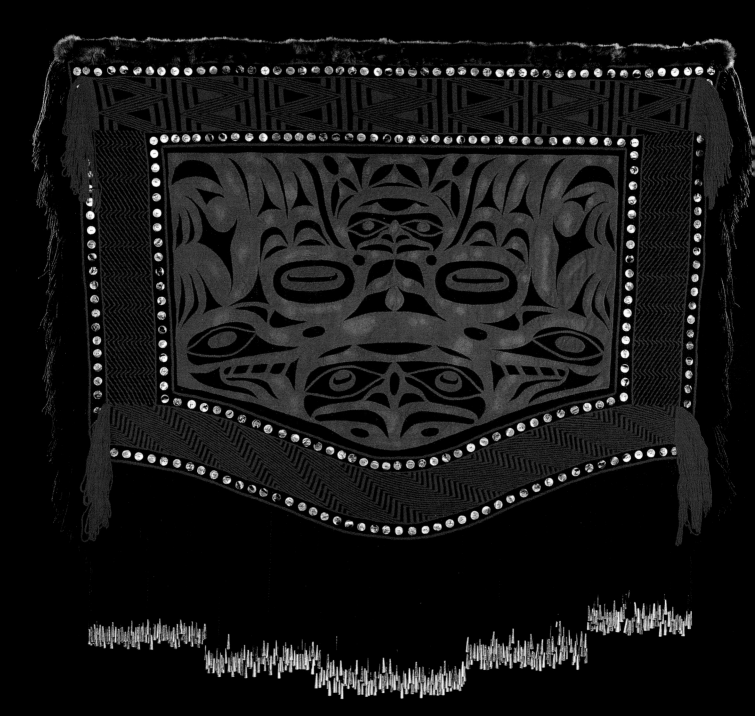

HAWK MOON

ROBERT DAVIDSON: The Hawk Moon is one aspect of the character of a crest from the village of Skedans, and it is a lineage crest of Terri-Lynn Williams, to whom I am married. I carved this pendant to celebrate her birthday.

The Northwest Coast has produced numerous highly regarded jewellers, but their reputations are seen much more for their contribution outside of our culture. In reality, however, there is a great internal demand within our culture for jewellery by major artists. Many people on the coast have commissioned or purchased jewellery from artists to display their clan or crests in daily life or to wear ceremonially.

Hawk Moon Pendant
on next page

Robert Davidson
Haida
yew wood, abalone shell
diameter 2½ inches

MOTHER OF LIGHTNING ROBE

CHERYL SAMUEL: This robe was created to respect and challenge the traditional techniques of ceremonial robe weaving. It is the first time that I used all three of the robe-making art forms in a single piece. It is woven in the Ravenstail technique, but the shape has been altered to the Chilkat five-sided format, and the appliqué is derived from the later button blanket tradition. The black and red colours, unusual for weaving, were also inspired by modern button blanket regalia.

I was given the name Nish-aloo-tsumti, "Mother of Lightning," by Tsimshian basket weaver Flora Mather. The woven designs in this robe all represent Lightning. The top border is the very popular Lightning design found on some of the most elaborate Ravenstail robes. For the side borders, I designed a new Lightning pattern, one that speaks of a storm in Ketchikan in which the lightning lasted all night. The bottom border is Spiral Lightning, a pattern which I saw on a cedar bark robe in the British Museum. This robe could have been woven on the southern coast.

The appliqué design is a Thunderbird and Wolves by Tsa-qwa-supp (Art Thompson). These are both crests owned by him. This is a Nuu-chah-nulth creation story of the birth of the humans from Wolves, who transformed into people. The Thunderbird witnessed this transformation and told the story.

In concept, this robe spans the entire coast, combining northern weaving traditions with a southern style design. Chilkat weavers used puffin beaks and deer toes to add sound and style to aprons and leggings; I turned to the prairie powwow tradition to echo their use and attached tin cones to the bottom of all the warp fringes. Abalone shell buttons are used to adorn the oldest leather regalia and new button blankets; by using them, and sewing tiny red glass beads into the holes of the buttons, I wished to capture the richness of the art forms which produced such spectacular regalia.

Mother of Lightning Robe
on facing page

**Cheryl Samuel and Tsa-qwa-supp
(Art Thompson)**
Northern style / Ditidaht (Nuu-chah-nulth)
merino wool, leather appliqué, fur, abalone shell
buttons, glass beads, tin cones
45 × 48 inches

THE TALKING STICK

STEPHEN BRUCE: The talking stick is always carved with the crests of the chief who owns it. In this case, the crests are Thunderbird, Bear and Raven. The three shield-shaped objects are coppers, which are symbols of great wealth owned by a chief and which are displayed at important ceremonial events. A copper has an implied value that increases each time it is publicly displayed. In some cases, a copper was broken and a piece of it was given as a prestigious gift or to challenge the recipient to reply with a gift of equal value.

The talking stick is a power symbol and a control mechanism in a circumstance where a group of high-ranking chiefs has gathered. The chief who is holding the stick has the authority to speak. No one can interrupt until the stick has been passed to someone else, who then may speak. The stick can also be passed to someone who has not chosen to speak because of political or family ties to others present, but who must offer an opinion or state a position upon receiving the stick.

The talking stick has become a prestigious gift and symbol beyond the Northwest Coast, and many prominent dignitaries, heads of state and corporate leaders have received talking sticks as gifts.

Thunderbird Talking Stick

Stephen Bruce
Kwakwa̱ka̱'wakw
yellow cedar, twine, copper, paint
73 × 15½ × 3 inches

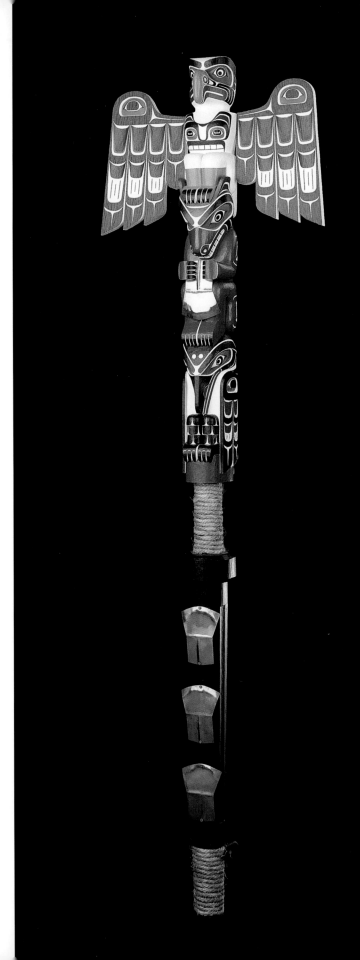

THE THUNDERBIRD

ROBERT DAVIDSON: The Hiilang is a supernatural bird also known as the Thunderbird because the clap of his wings caused thunder and the blinking of his eyes caused lightning. This great bird would descend from the sky to prey on Killerwhales, a creature with no enemies in the natural world.

Stories about the Thunderbird are nearly universal on the Northwest Coast, though distinctions are made in terms of its use as a crest. The Thunderbird is a crest among the Haida, and in our family, it is carried by Leslie Williams, the daughter of my brother Reg Davidson.

Hiilang (Mystery of the Sky)
below and on facing page (detail)

Robert Davidson
Haida
red cedar, cedar bark, operculum shell, paint
16 × 38 × 11 inches

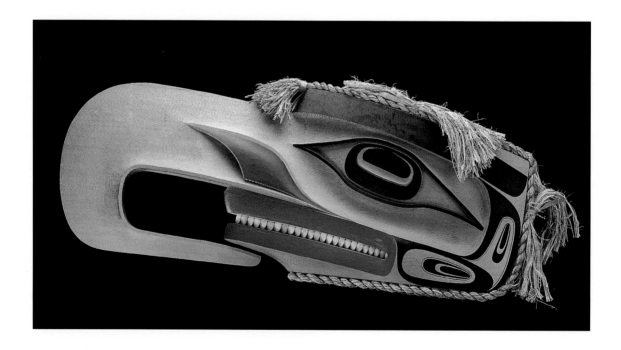

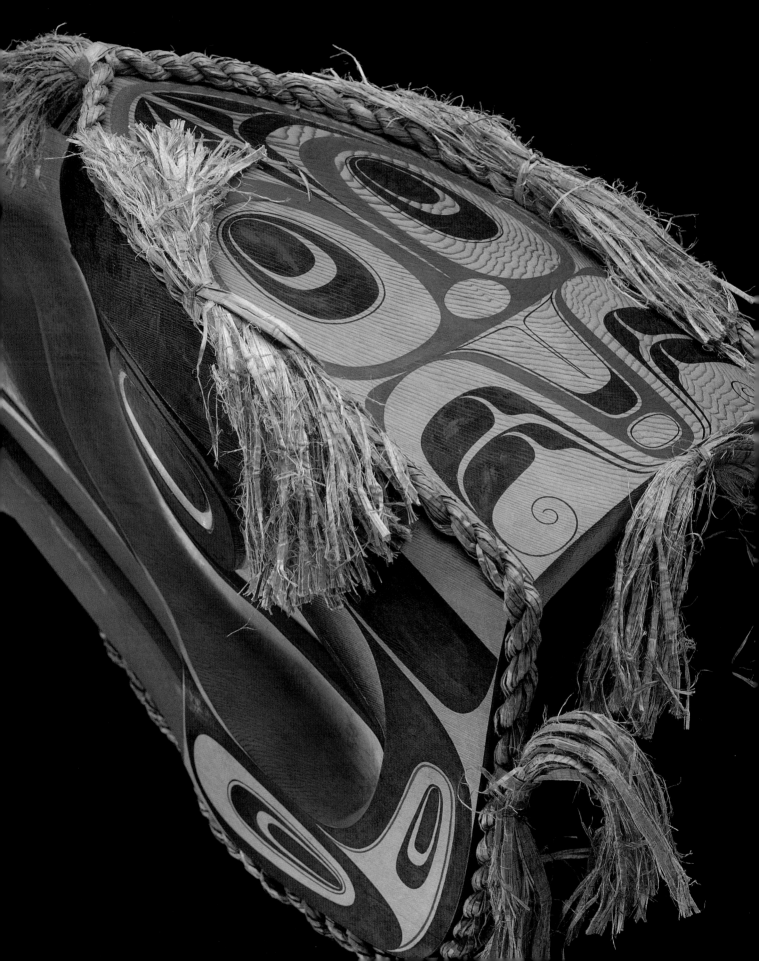

THE THUNDERBIRD

RICHARD HUNT: The Thunderbird headdress is used in the Hamaṫsa (or wild man of the woods) dance. The Thunderbird headdress is worn after the Hamaṫsa initiate or wild man has been tamed.

The rights to this mask were given to me about fifteen years ago by Tom Willie at a potlatch. At this potlatch, I was also given the name Gwe-la-yo-gwe-la-gya-lis, which means "a man who travels and wherever he goes, he potlatches."

When I dance with my family, I use the headdress of Ḵulus or immature Thunderbird, which is the younger brother of Thunderbird. In my family, the Thunderbird belongs to my brother Tony Hunt Sr.

The face on the bottom of the beak of this Thunderbird headdress is a design representing one of my ancestors.

I don't think of what I do as art but as cultural property. In this way, we may be able to keep and hold onto our culture.

Thunderbird Headdress

Richard Hunt
Kwakwa̱ka'wakw
red cedar, cedar bark, cloth, feathers, paint
11 × 18 × 12 inches

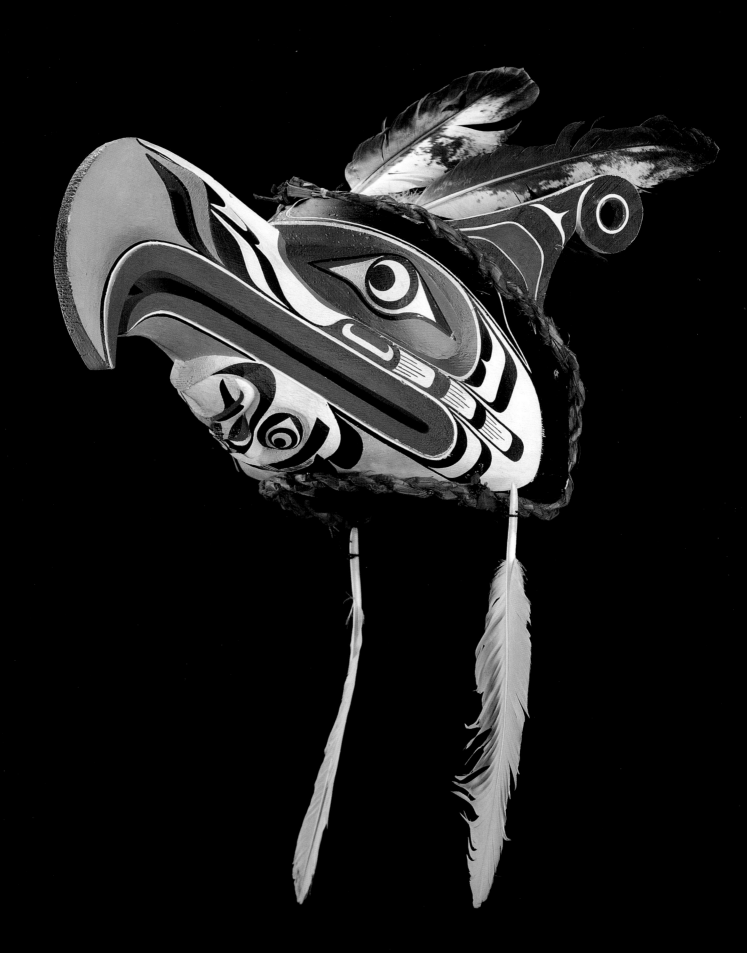

THUNDERBIRD AND KILLERWHALE

RICHARD HUNT: This is the model for a monumental sculpture that will include a 15½ x 9-foot Thunderbird and a 16-foot Killerwhale. It was commissioned for the new domestic terminal of the Vancouver International Airport.

The Thunderbird is swooping down to eat the Killerwhale, which is its favourite food. The Killerwhale, in turn, has a seal in its mouth. The design motifs include a Whale on each side fin, a Bear on the dorsal fin, and an Eagle on the tail and in the blowhole. The Eagle is the main crest of the people of Fort Rupert, and all the figures and designs on this piece belong to the Kwakwaka'wakw people. Killerwhales are said to be the spirits of high-ranking chiefs.

The Thunderbird is represented in the regalia of the tamed Hamatsa initiate. The Killerwhale is used in the Klasala or Peace dance.

Thunderbird and Killerwhale

Richard Hunt
Kwakwaka'wakw
yellow cedar
14 × 17 × 7 inches

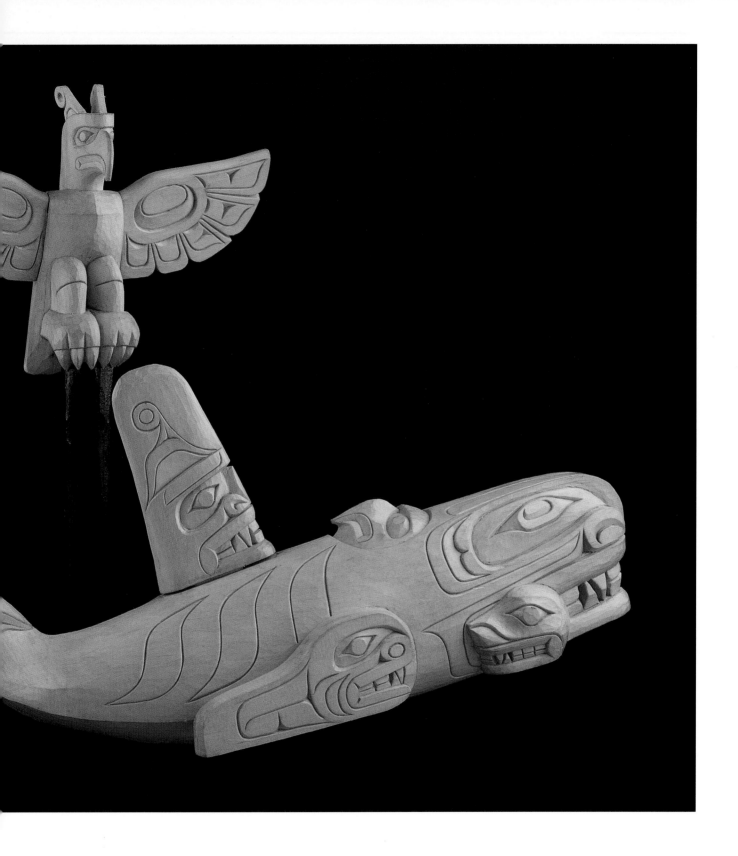

THE SKY WORLD

THE HUXWHUKW AND THE EGRET

SIMON DICK: The Huxwhukw is one of four spirit birds that are part of the Hamaṭsa dance ritual. The other three are the large Crooked-Beak (Hunsumith), the female counterpart Crooked-Beak (Gatukumith) and the Raven (Gwakwumith). The birds are disciples of Baxwbakwalanuxwsiwe', the cannibal spirit of the north. The Hamaṭsa is the most important ritual of the Tseka, or red cedar bark rituals, which are dances performed by members and initiates of secret societies.

The Huxwhukw mask is used as part of the initiation rites to the Hamaṭsa society. The scale of the mask and the dance itself are part of the challenges that test the worthiness of the dancer.

The Huxwhukw is also a part of the Aṭlakim dance groups that represent the supernatural gifts of the forest. This series of dances uses over forty masks that are owned by various families and requires the collective participation of all to present the entire set. During the ceremony, the masked dancer leaps from an elevated platform, often above the entrance door, and lands in the central dance space. In some cases, dancers wearing two Huxwhukw masks, a male and a female, leap from the platform in unison. This is rarely seen, although they were danced for my great-grandfather and were part of his family property.

The Tseka and Aṭlakim dances are distinct from the group of dances known as the Tlasala, which are family, personal and celebration dances.

THE EGRET

SIMON DICK: The Egret is a relative of the Heron, which has a much more prominent position in Northwest Coast mythology. The Egret is a very elusive bird and is rarely seen by people. My first attraction to the Egret was seeing its coloration, which is identical to the green, grey and brown commonly used by southern Kwakwaka'wakw artists. I am also attracted to birds because I am a dancer, and the opportunity to learn to imitate their movements is a unique challenge.

There is no historical model that places limitations on which creatures have a place within ceremonial art. This allows the art form to evolve and for new dances and masks to earn positions within family-held rights. As an artist, I have explored contemporary interpretations of known characters as well as researching new or lesser known creatures that live on the Northwest Coast.

Two Bird Masks

Simon Dick
Kwakwaka'wakw

top
Huxwhukw Mask
red cedar, cedar bark, glass, paint
16 × 48 × 9¼ inches

bottom
Egret Mask
red cedar, cedar bark, paint
11 × 39 × 8 inches

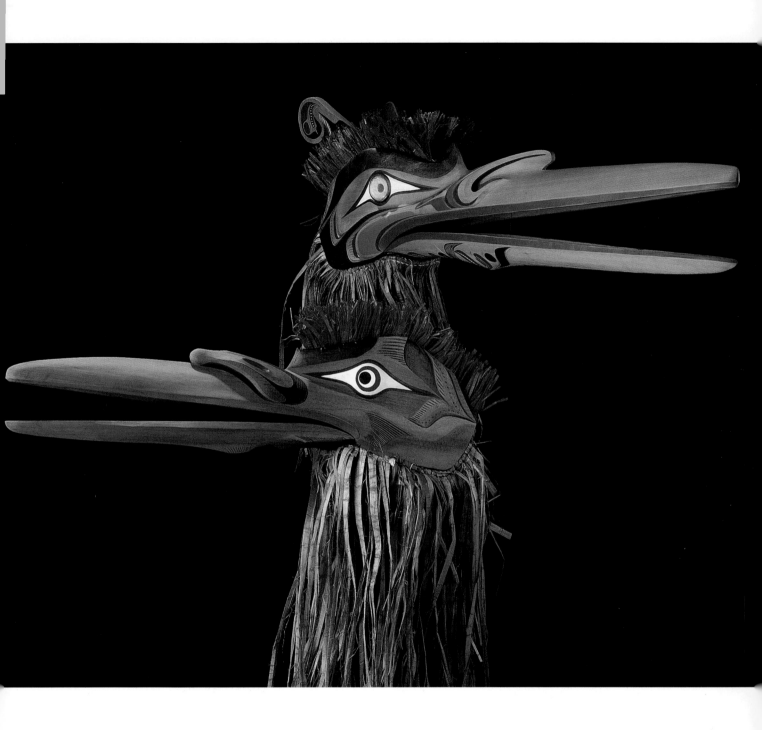

THE SKY WORLD

EAGLE IN ITS FAVOURITE FORM

BILL KUHNLEY: The stories about Raven tell of a world where the animals were once all white. Largely through the interference of Raven, the animals were painted or altered to their current colours. There is a similar idea in the carving of a mask in which the wood represents a natural and favourite form of the animal. The paint, in formline design, imitates the colours and characteristics of the creature. In the later stages of my four-year apprenticeship with Robert Davidson, I watched and assisted on several pieces where the wood became the subject of the piece—equal to the form being carved. One of these, the Spirit of Cedar (pages 60 and 61), is included in this book.

The material contributes so much to the understanding of the work being made. There is an appreciation of the form of the animal as seen without colour, and as a memory of how the world looked when some of the decisions on how things should look were still being made.

Eagle in Its Favourite Form

Bill Kuhnley
Nuu-chah-nulth
red cedar, cedar bark, horsehair,
operculum shell, copper
12½ × 9 × 8 inches

46

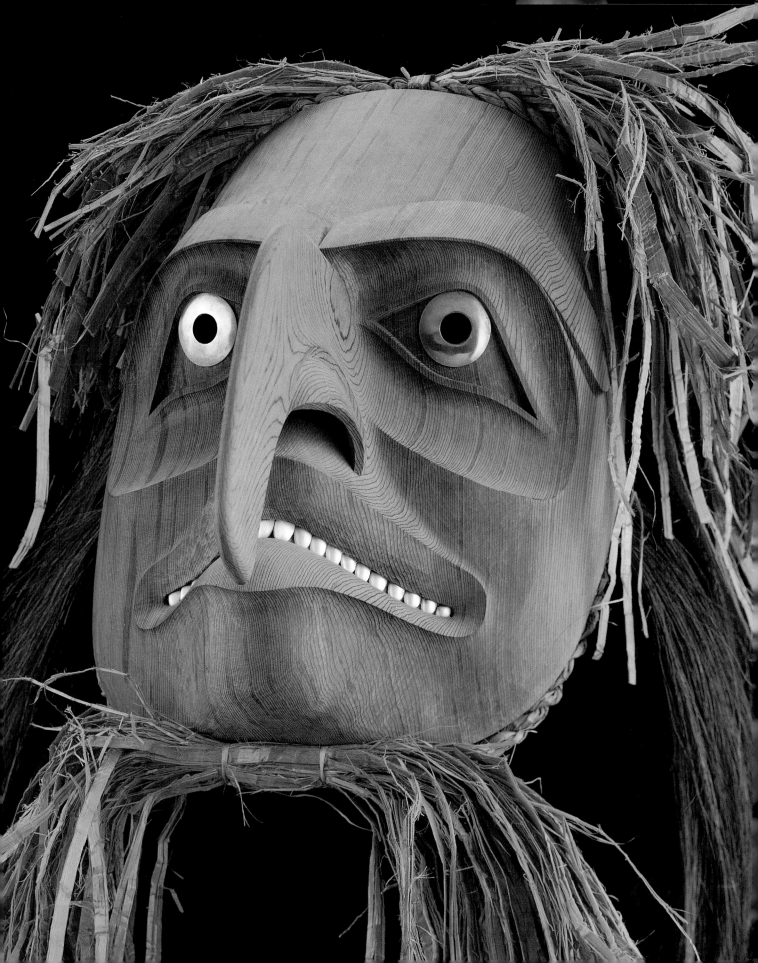

THE FRONTLET

The frontlet is a forehead mask attached to a woven headpiece. It is worn by chiefs and high-ranking individuals as a display of crests and status. Frontlets are often decorated with materials that are symbols of wealth and power: abalone shell, operculum shell, sea lion whiskers, feathers and ermine pelts.

For a ceremony, a frontlet may be loosely covered with eagle or other down, which floats away and lands on the people nearest the dancer. To be touched by the down is a sign of luck and honour.

In recent times, artists have been using precious metals, either inlaid or carved and etched with designs. Frontlets were often carved by someone from a different clan, and the inlays from materials presented as gifts. The owner is making a statement of honour and respect, which is often best achieved by those looking from the outside.

These four variations of the frontlet show four distinct artistic and tribal styles. Three of them display Eagle crests and one a Raven crest. The story associated with the Raven frontlet is told by Tsa-qwa-supp (Art Thompson).

RAVEN AND THE FIRST HUMAN BEINGS
TSA-QWA-SUPP (ART THOMPSON): This frontlet is one of my interpretations of a legend about the birth of our people. Raven was lonesome after creating the world, and, in his loneliness, he went to the beach to look for food. After eating some mussels, Raven's loneliness overcame him, and he began to weep uncontrollably. With tears falling from his eyes, he scanned the beach for anything that resembled a companion. Nothing. He bowed his head and wept more intensely. Mucous started to flow from his nostrils and into an open mussel shell, along with some tears. From this moment of his emotional breakdown started the forming of the first human beings in the mussel. Days later, he returned for another feed

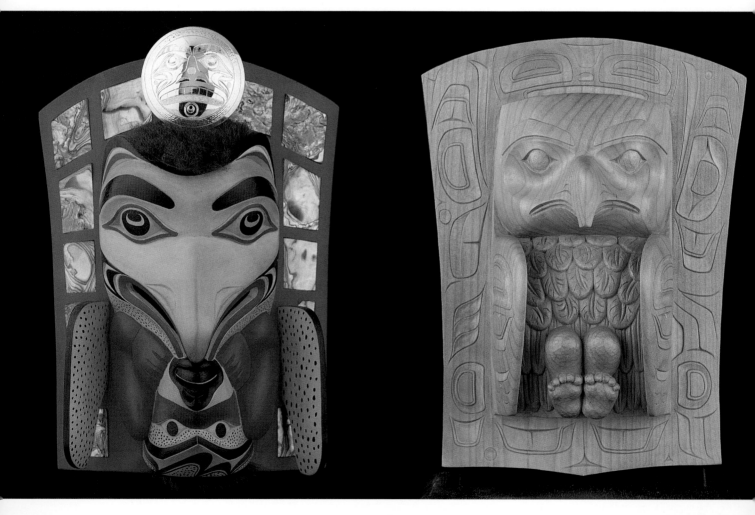

THE SKY WORLD

of mussels, when he heard strange noises coming from the mussel bed. Curious, he started to seek out the noises, going from one mussel to another, eyeing them carefully. Finally, he found the one that the noises were coming from. Tapping it gently and hearing a noise in response, he started to talk to the shell: "Open your shell, mussel. Why are you so noisy?" The mussel opened and out came the first human beings.

Four Variations of the Frontlet

on facing page, left
Raven and Human Frontlet

Tsa-qwa-supp (Art Thompson)
Ditidaht (Nuu-chah-nulth)
alder, silver, abalone shell, paint
8 × 6 × 4 inches

on facing page, right
Eagle Frontlet

Norman Tait and Lucinda Turner
Nisga'a
alder
10 × 8 × 4 inches

on this page, left
Eagle Frontlet

Chuck Heit
Gitxsan
silver birch, abalone shell, gold, paint
7 × 6 × 4 inches

on this page, right
Eagle Frontlet

Reg Davidson
Haida
red cedar, abalone shell, copper, paint, sea lion whiskers
8 × 4 × 3 inches

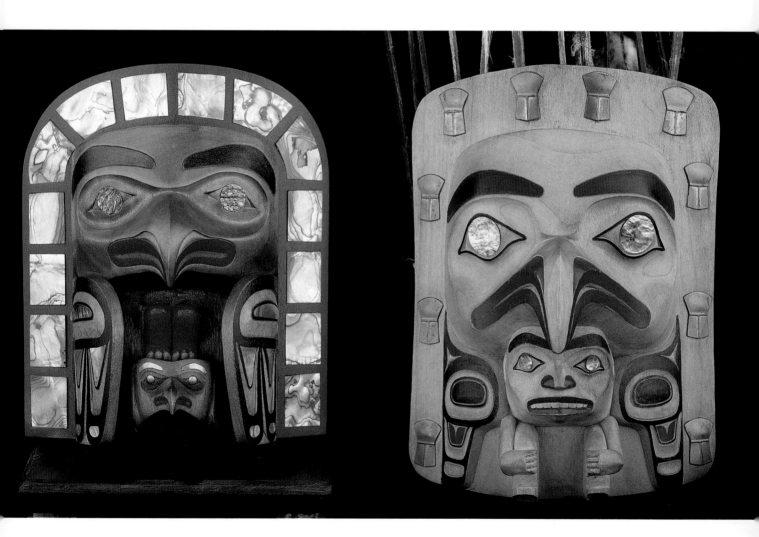

RAVENSTAIL ROBE

DELORES CHURCHILL: The Ravenstail is the oldest known robe-weaving tradition on the Northwest Coast. This robe was woven in the village of Old Massett on Haida Gwaii and is possibly the first one woven here in over 150 years. The weaving process was witnessed by many people in the village, and there was a great deal of enthusiasm and interest. It was also a summer of catching crab and harvesting the natural bounty of the islands, as well as weaving, all traditional activities.

The top border is known as a Raven's Hood design, and the next forms are Raven's Tail, followed by a Haida tattoo design. The side border, I originally called Fishnet; this pattern was not used for any existing Ravenstail robe. I have since changed the name to Spider Web, which is a basket-weaving pattern. The bottom border represents the Haida story of the first people coming out of a cockleshell, although in most stories, Raven discovers the first people emerging from a clamshell after the great flood. I decided on a cockleshell because on Rose Spit, the sandy beach where the story takes place, cockleshells are what you find. The sea otter pelt on the top represents the early fur trade with China; many Haida were employed on schooners hunting sea otters. The abalone shells refer to Haida journeys to California to trade for these shells and to establish trade routes and contacts along the way.

Ravenstail robes were never common, as they were considered the ultimate gift or commissioned by high-ranking chiefs. Production was restricted due to the complexity of the weaving. Most of the documentation of the Ravenstail robes was done about two hundred years ago in a few drawings by Russian artists and later in some archival photographs. Only a few of the robes from this period are still in existence. There are also a few fragments of other robes that offer some indication as to the design patterns. There is a photograph of a Haida chief wearing a Ravenstail that was taken in Victoria around 1920; it was not included on Cheryl Samuel's book on the Ravenstail as it was not known about at the time.

This robe was woven for a private collector who believes in maintaining the ceremonial role of these important weavings. It has been loaned on several occasions to be worn and danced. Robert Davidson danced with this robe at the Sealaska Heritage Celebration '96 in Juneau, Alaska, and he borrowed it again for his wedding in 1996 to Terri-Lynn Williams. This was the first traditional Haida wedding in about a hundred years. This robe will continue to be a part of history that is still waiting to be decided.

Ravenstail Robe

**Delores Churchill and
Evelyn Vanderhoop**
Haida
merino wool, fur, abalone shell
51 × 62 inches

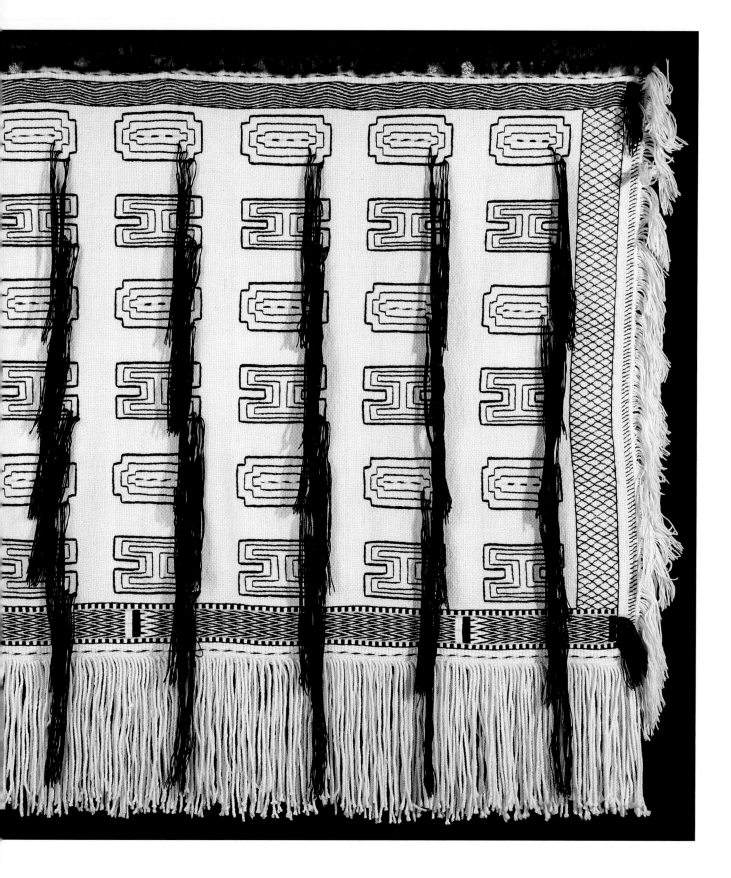

THE SKY WORLD

THE WIND

KEN McNEIL: To each of the four winds is attributed a separate and individual persona. Here, those four distinct personalities are shown merged into one mask, asserting their own identities and at the same time sharing their collective identity.

The Wind

Ken McNeil
Tahltan / Tlingit / Nisga'a
alder and goat's hair
13½ × 11 × 6 inches

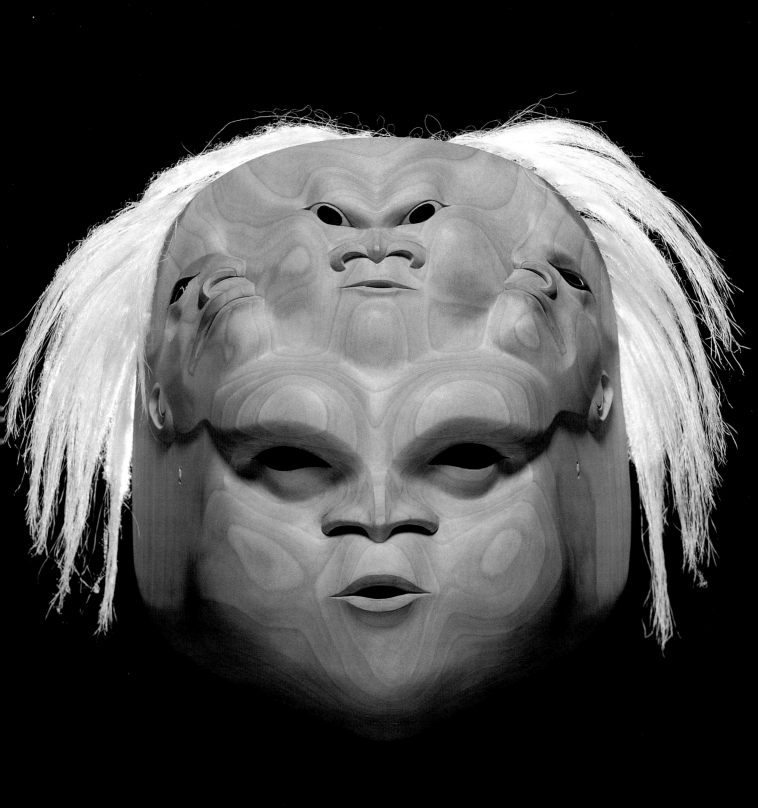

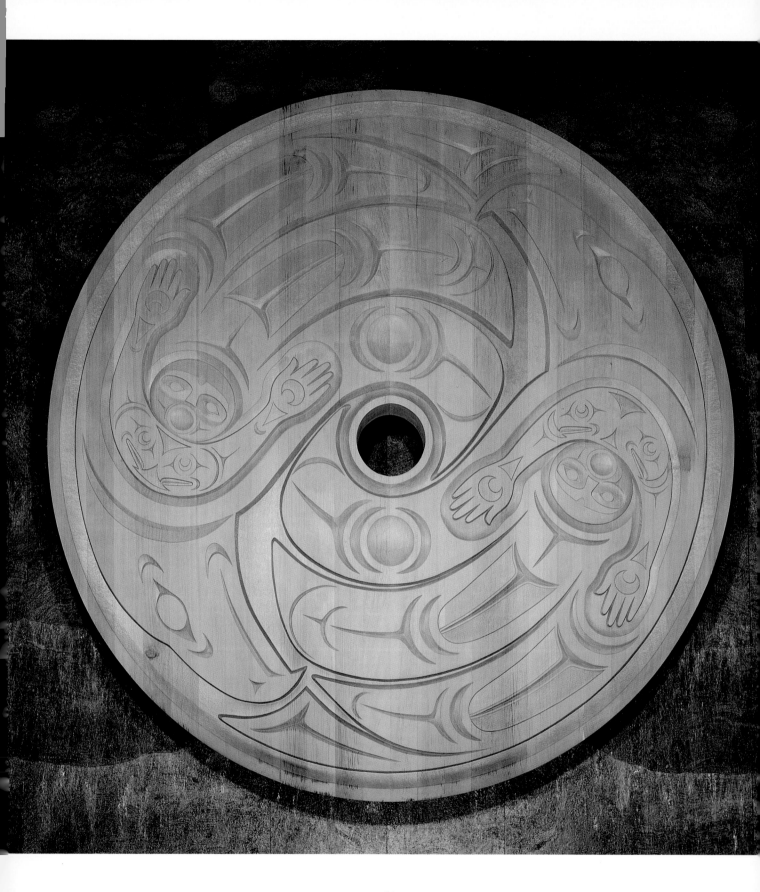

THE SKY WORLD

FLIGHT

SUSAN POINT: This monumental spindle whorl* was commissioned by the Vancouver International Airport Authority in the fall of 1994 for its new terminal building.

The imagery in this spindle whorl refers to flight, reflecting the spirit of the Pacific Northwest Coast as well as traditional Coast Salish art by using design elements such as crescents, U-forms and wedges or V-forms. As birds, animals, and human forms (as well as other images) were often represented on traditional Coast Salish spindle whorls, I felt that it was important this design represent not only the theme of "flight" relating to the airport but also the human element—people between places.

The image depicts two Eagles, two human forms, Salmon motifs, and the Moon, Sun and Earth. The Eagle, which is a symbol of great power, is designed around the image of a man whose arms are raised, welcoming visitors and a gesture of flight. The upper torsos of the human figures represent the Coast Salish people, whose traditional lands include the airport and the city of Vancouver. On their chests are Salmon motifs that represent the fact that the Coast Salish still live and fish along the shores of the Fraser River. Salmon is the sustenance of life and a symbol of wealth for our people.

* see note about spindle whorl on page 18

Flight

Susan Point
Coast Salish
red cedar
diameter 16 feet

THE SKY WORLD

ECHO AND TRANSFORMATION

SIMON DICK: The Echo mask originated at Blunden Harbour in northern Kwakwaka'wakw territory and depicts the evolution of creatures from the sea onto the land and into the sky. It is also a statement about the cycle between life and death, ending with the power to fly. There are many creatures that bridge two worlds. One is the Eagle, who travels from the sky to the land and into the water to catch fish. Another is the Frog, who moves freely between the land, water and deep forest.

The word "echo" refers to the technique used by several singers behind the dance curtain to throw their voices so the sounds appear to be coming from the masked dancer. The dancer is not a singer, and in fact cannot sing or speak, as he must grasp each of the interchangeable mouthpieces in his teeth, using a tooth bar that fits through the mouth of the mask. The Echo is also about changing the dance movements to capture the physical nature of each character represented by the different mouthpieces.

This mask is danced with the help of an assistant, or by the dancer wearing a cloak with pockets to hold the various mouthpieces. In some cases the mouthpieces are carried in a basket. The dancer turns away from the audience and switches mouthpieces by sleight of hand.

It is unusual to see an Echo mask whose mouthpieces all represent birds, although there are many birds that embody the notion of transformation and sharing dual worlds.

Echo Mask
Human (below centre) *with five interchangeable mouthpieces,*
Raven (below left), *Kulus* (below right),
Thunderbird (facing page),
Heron and *Ouzel* (not shown)

Simon Dick
Kwakwaka'wakw
red cedar, cedar bark, copper, paint
19 × 9 × 7 inches

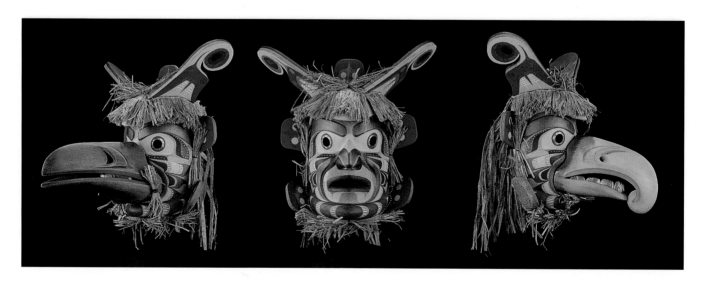

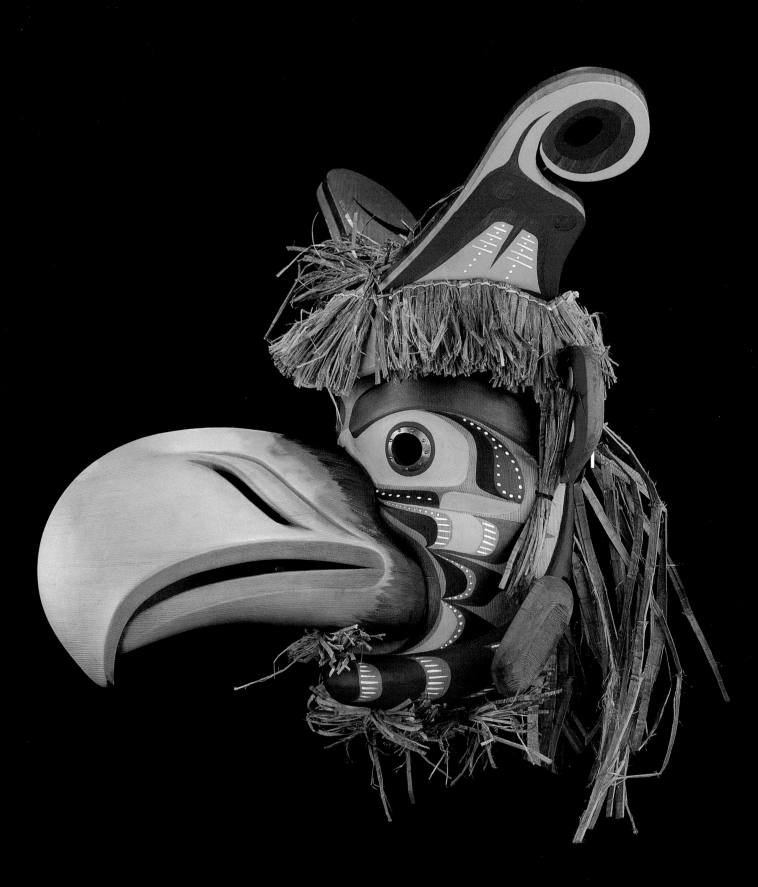

THE
MORTAL
WORLD

SPIRIT OF CEDAR

ROBERT DAVIDSON: There are many stories throughout the Northwest Coast that tell of the wisdom, power and energy of the great cedar trees. The forest was deemed to be part of the spirit world, and people were sent into that world in search of spiritual guidance. The cedar trees were revered as a gift that offered material for housing, transportation, clothing, tools, and objects for ceremonial and everyday use. In recent times, we have lost our understanding of this important gift.

This past year, I participated in a fly-over of Haida Gwaii with a group of chiefs and elders to witness the effects of clear-cut logging and to measure the devastating effect that this has had, and will have, on watersheds, salmon stocks, wildlife and bird populations. It was the same year that the golden spruce, a one-of-a-kind tree that grew on the bank of the Yakoun River between Skidegate and Massett on Haida Gwaii, was destroyed by an act of political vandalism. The reality of all these losses was felt immediately and will be felt forever.

The time is now to pay close attention to what is being told to us by the trees. The expression in this mask is one of agony—showing something that only lives in ancient trees. It is unpainted for several reasons. First, it shows the wood in a state of vulnerability—paint can disguise true feelings and hide mistakes. Second, there are challenges in carving red cedar. The wood is soft and easy to carve; therefore, it is also the most difficult. It is unforgiving, and the softness makes it a difficult wood to capture detail and definition.

The only decoration is cedar bark, which is the natural skin of the tree. There are no teeth, carved or inlaid; I was thinking of the deer mask used in the Peace dance because it has no fangs. There is an edge that I have attempted to express in this mask, an edge that is between the power of the subject and telling a story using only the unadorned materials.

Spirit of Cedar (T'suu Sganwee)

Robert Davidson
Haida
red cedar, cedar bark
13 × 10 × 8 inches

THE MORTAL WORLD

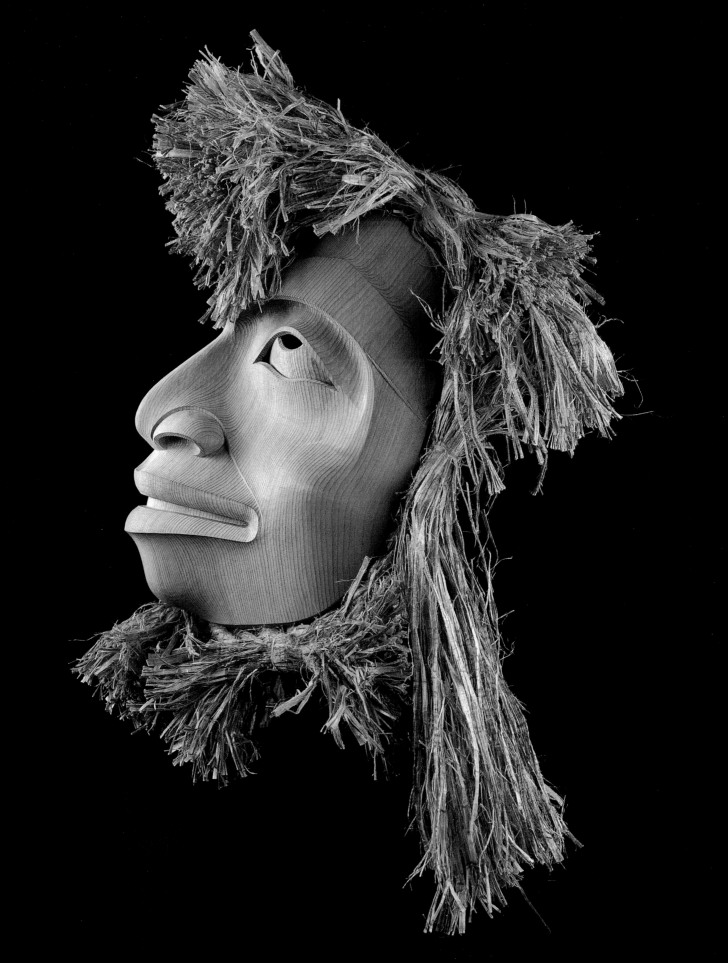

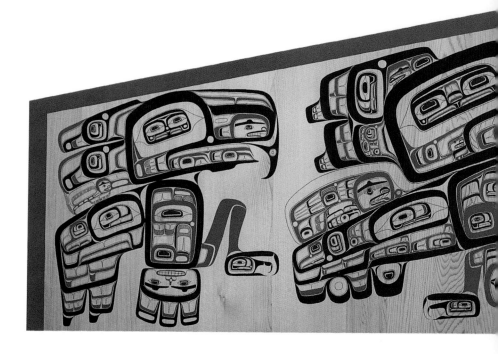

TSIMSHIAN COSMOS

LYLE WILSON: This model of a house-front screen was created from the fragments of one that once graced a Tsimshian bighouse. The model is one-sixth of the original housefront's estimated size, which was perhaps 50 by 18 feet. Few people realize that monumental painted screens preceded the more familiar monumental totem poles.

All eight of the surviving board fragments of the housefront at the University of British Columbia Museum of Anthropology constituted only 20 per cent of the whole—and less than 15 per cent of the painted image could be recognized even from infra-red photographs. So my small re-creation was still a formidable task, made possible by the help of the staff and associates of the Museum of Anthropology.

The gaping areas missing in the image meant the final painting became a personal interpretation. Another artist may have resolved the missing areas quite differently.

There are many theories and stories about the origins of Northwest Coast art. There is one old, perhaps relevant, story about a supernatural creature that guarded the wealth of the world. This creature was depicted on bentwood boxes, symbolically guarding the treasures within. Bighouses stored the history, people and clan treasures and were the metaphorical equivalent of bentwood boxes. The original screen may have displayed such a guardian creature along with clan crests.

The precontact Pacific Northwest Coast was a primal environment of wild seas and landscapes, inhabited by unimaginable quantities of life forms and spirits. An artist was the medium that distilled that hostile world into painted manifestations—both real and imagined. On my screen, the many "spirits" contained within the central guardian creature and two flanking, raptorial friends reflect this old world.

The person who painted the original screen was a genius—perhaps the greatest Northwest Coast painter of all. I honour both him and his magical world by calling my painting *Tsimshian Cosmos*.

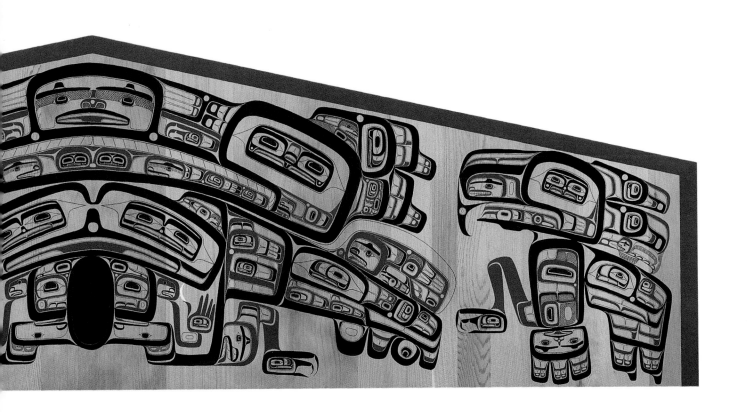

Tsimshian Cosmos

Lyle Wilson
Haisla
red cedar, paint
27¼ × 98 inches

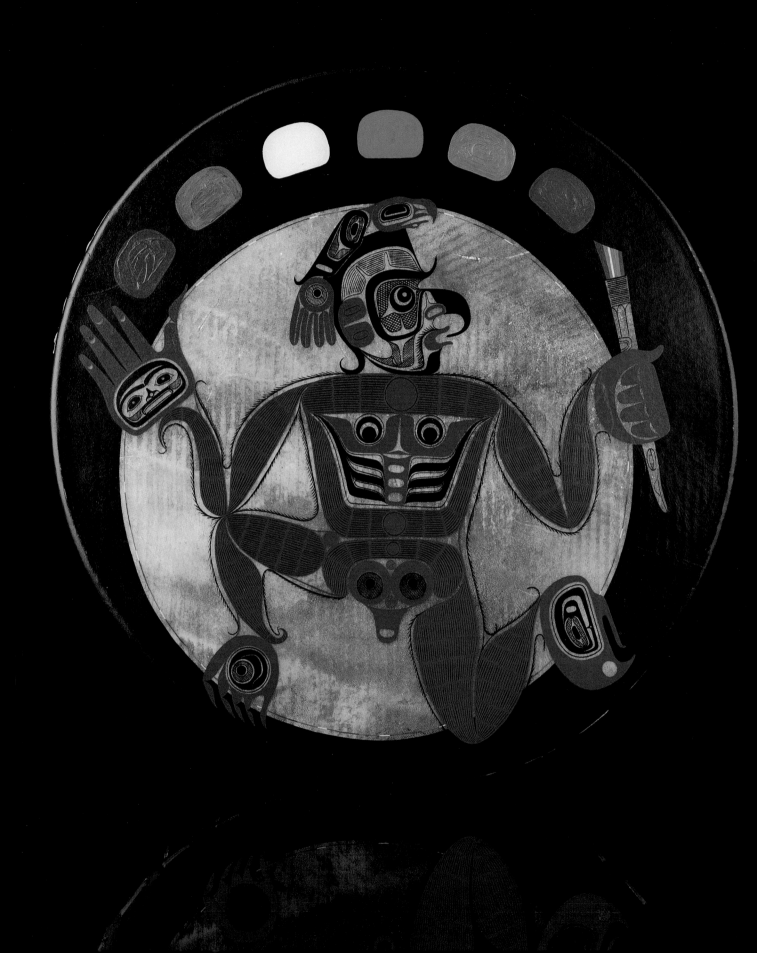

COLOURS DRUM

LYLE WILSON: On the Northwest Coast, the drum is considered to be both an ancient voice and the metaphorical heartbeat of the people. In the old days, drums were used in shamanic sessions as well as potlatch pageantry.

A single drumbeat is like a pebble thrown into a calm pond of water: the ripples spread outward in a circular pattern in perfect union, as if choreographed. Every nook and cranny of the pond is touched by the ripples. Sound waves are similar, only they move in atmospheric space.

A single blow to the drum produces a strong thundering bass boom that rumbles, quivers and resonates with an emotive quality, evoking ancient memories. Drummers aware of the emotional impact of their instrument can produce a sound arena where the heartbeats of many are transformed into a single pulsating entity.

I wanted an image that reflected the interwoven history of the drum, people and art. The final image is a blend of new and old iconography, which is open to the interpretation of the viewer.

Someone asked if this was a self-portrait. It isn't. However, the figure represents the Artist: intelligent, inquisitive, egotistical and dressed a bit unconventionally. Ironically, these same terms also apply to the mythical Raven—the Trickster! The Raven holds a special place in the history of the Northwest Coast because he often introduced new things to people. The Artist's left hand holds a traditionally shaped paintbrush, the handle painted with the image of Raven. Symbolically, the Trickster is introducing the colours of the rainbow. Understandably, the Artist is somewhat confused about these new colours, as his precontact palette consisted of black, red and green. Somehow it seems natural that both the Artist and Raven are part of this event.

The Artist stands in front of a space that symbolizes the circular doorway of a traditional bighouse. Once a person stepped through the doorway, it was the same as being reborn.

The Artist is also like a shaman who steps through the magical doorway leading to the unknown spirit world. His lack of dress symbolizes commonly held fears of vulnerability buried deep within the human psyche. His Eagle crest, situated atop its birthplace, indicates that regardless of its physical presence, the crest's power instills psychological strength that allows him to face, endure and battle any danger. The paintbrush becomes a means of expressing his thoughts.

When an artist is working on a piece, intuition tells him when the work is finished. To add more would weaken the integrity of the piece. That same intuition tells me to stop my story and let the images and viewer continue their own dialogue.

Colours Drum

Lyle Wilson
Haisla
deerhide, red cedar, paint
diameter 20 inches

HOW THE HAT GOT ITS DESIGNS

ISABEL RORICK: A long time ago, when the first spruce root hats were woven by the Haida, they were very plain, with no decorative weave. A spider came along and looked at the hat, and she thought to herself how she could improve the weave. She quickly went to work, spinning her finest web, and covered the crown of the hat. She stood back and admired what she had done.

Slug happened to be nearby. Spider was so proud of her accomplishment that she boasted to Slug about her beautiful work. Slug decided that she could make a design that was just as beautiful. Slug came down the hat, marking her zigzag trail on the brim. These two designs are still woven today.

THE STORY OF THE FIRST BASKET

ISABEL RORICK: A very long time ago, food was very scarce among the Haida. A young girl took more than her share of the family meal. Her mother scolded her shamefully and scratched her face. During the night, when everyone was asleep, the girl fled with her older sister to a place beside a beautiful lake. There, they encountered a spirit helper in the form of a man (some say that it was really Raven in disguise). Learning of their predicament, he instructed them to pull up spruce roots, split them and weave them around their thumbs to make a basket. He then told them to put one of each kind of food that grew in abundance nearby into the basket. The basket grew with the bounty of food. The man shook the basket to shrink it back to its original size for easy travelling. The girls returned with the basket to their village, where they were welcomed back with tears of happiness and great joy.

The older sister set the basket down, and it grew magically, revealing the bounty of food. Everyone in the village received a gift of food. When their mother received her gift of food, she died of shame, as it came from the daughter she had punished so severely.

This collection features three variations of the four Haida hat styles. The short brimmed hat (right) is worn in dances so the face of the dancer can be seen. The wide brimmed example (centre) of the same style was for ceremonial use and worn by the upper class. The hat with the conical rings (left) is a potlatch hat, and each ring indicates the number of major potlatches given by the owner. Missing is the coarsely woven hat used in daily life.

Three Variations of the Spruce Root Hat

Isabel Rorick
Haida
Potlatch Hat (left): diameter 10 × 14 inches
Ceremonial Hat (centre): diameter 15¾ × 8 inches
Dancer's Hat (right): diameter 14 × 7½ inches

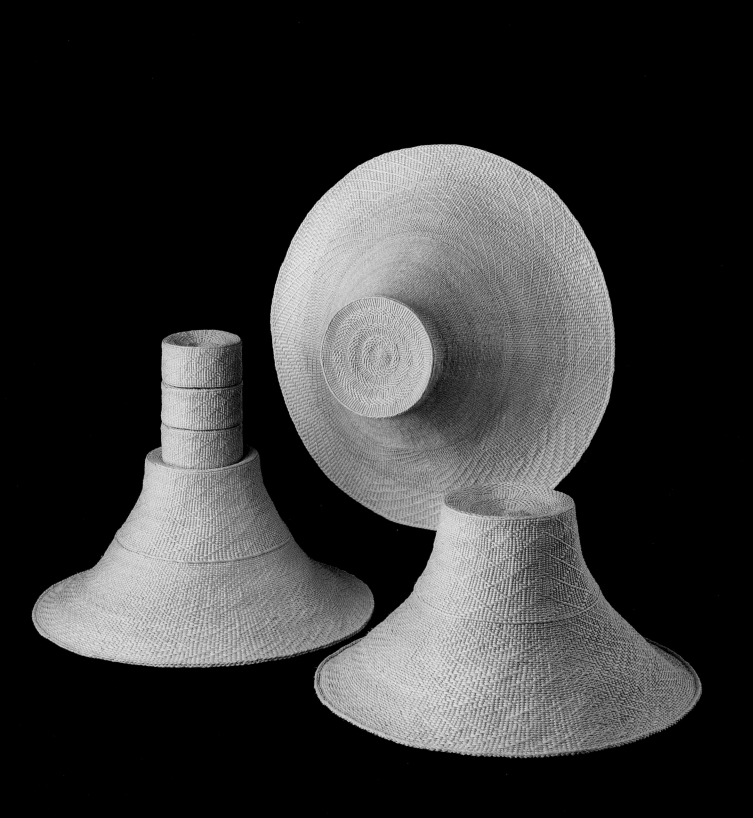

TRADITIONS AND GLASS

PRESTON SINGLETARY: Glass is among the newest mediums to be adapted to Northwest Coast imagery, possibly because the two have a shared artistic legacy of being fine art as well as for utilitarian purposes. I have had the privilege of studying at the Pilchuck Glass Studio in Stanwood, Washington, which has produced some of the most renowned glass artists in the world. The studio is in an environment dominated by Northwest Coast art and supported by many of the collectors who also supported both the contemporary and historical artists of the Northwest Coast. I have been viewed as a bridge artist between these two artistic traditions, an exciting point of reference in which to make art. Glass and wood have a natural affinity that has been recognized by many people.

There are several objects used by Northwest Coast cultures that I have explored in glass because they have a vessel-like nature. A classic Coast Salish spindle whorl* has become a dish or sculptural piece; a Tlingit potlatch hat, based on the classic spruce root hat, has been represented in glass as both a sculpture and a container; and the totem pole, which is symbolically a vessel of stories and family history—and was on some occasions used to hold the ashes of deceased chiefs—becomes a true vessel.

Glass offers some unique possibilities towards pushing the art a step further. The transparency of the glass, mixed with opaque flat formline designs, creates shadow effects beyond both the two- and three dimensional forms of the piece itself. Glass also is activated by light, as were the ceremonial pieces made to seen by firelight. For a culture with a history of creating dramatic effects in stagecraft, this offers interesting possibilities.

* see note about spindle whorl on page 18

* see note about spindle whorl on page 18

Four Works in Glass

Preston Singletary
Tlingit

on this page
Coast Salish Bowl (left): diameter 18½ × 3 inches
Northern-style Totem Pole Vase (right):
diameter 5½ × 17½ inches

on facing page
Inverted Hat, Tlingit Eagle (left):
diameter 17½ × 10 inches
Potlatch Hat, Tlingit Wolf (right):
diameter 16 × 17 inches

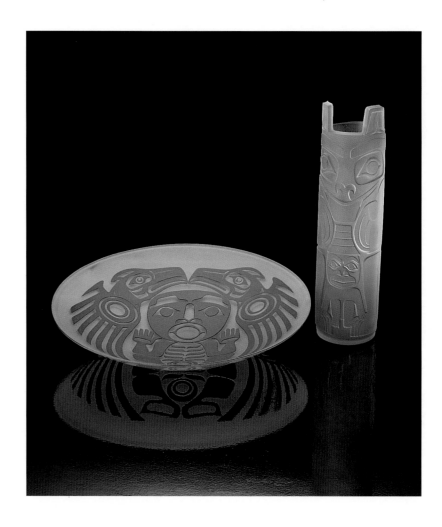

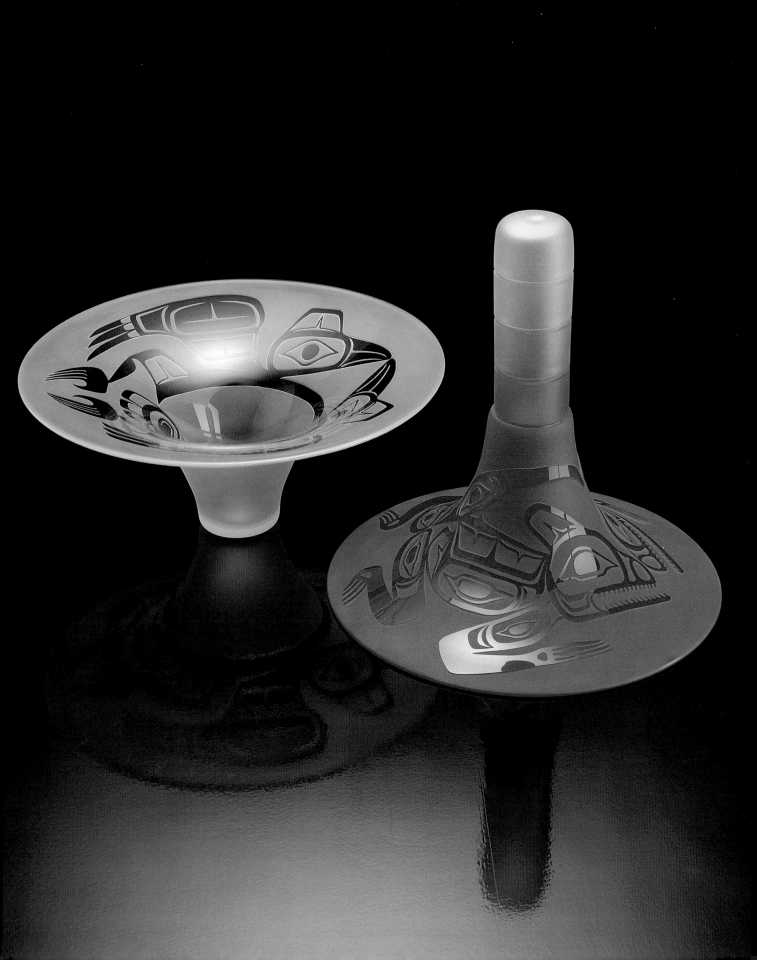

THE GRIZZLY BEAR

GLENN TALLIO: In Nuxalk culture, the Grizzly Bear is one of several cannibal beings that appear in one of the most important dances of the winter ceremonies held by the Hamaɫsa secret society.

The Grizzly is already present when the initiates, who are earning positions within the Hamaɫsa society, arrive in a possessed state to dance one or all of the three cannibal bird masks. The Grizzly does not dance with the birds, but appears alone or at the end of their performance. The Grizzly is the guardian of the house of the cannibal monster, of which the three birds are also attendants. The Grizzly is a chief's prerogative.

In the past, a full-fledged Hamaɫsa would have danced a cycle of twelve years, four years through each of three stages. Each stage involved feasting, giving gifts, distributing payments and other ceremonial costs. Information relating to secret societies was carefully guarded and never talked about. This is equally true today, in order to preserve the traditions that have been in place for hundreds of years. This is knowledge that secret society members acquired over many years of participation, so they have no need to talk about the dense layers of meaning and responsibilities.

Bear Headdress

Glenn Tallio
Nuxalk
red cedar, cedar bark, paint, cloth
12 × 18 × 11 inches

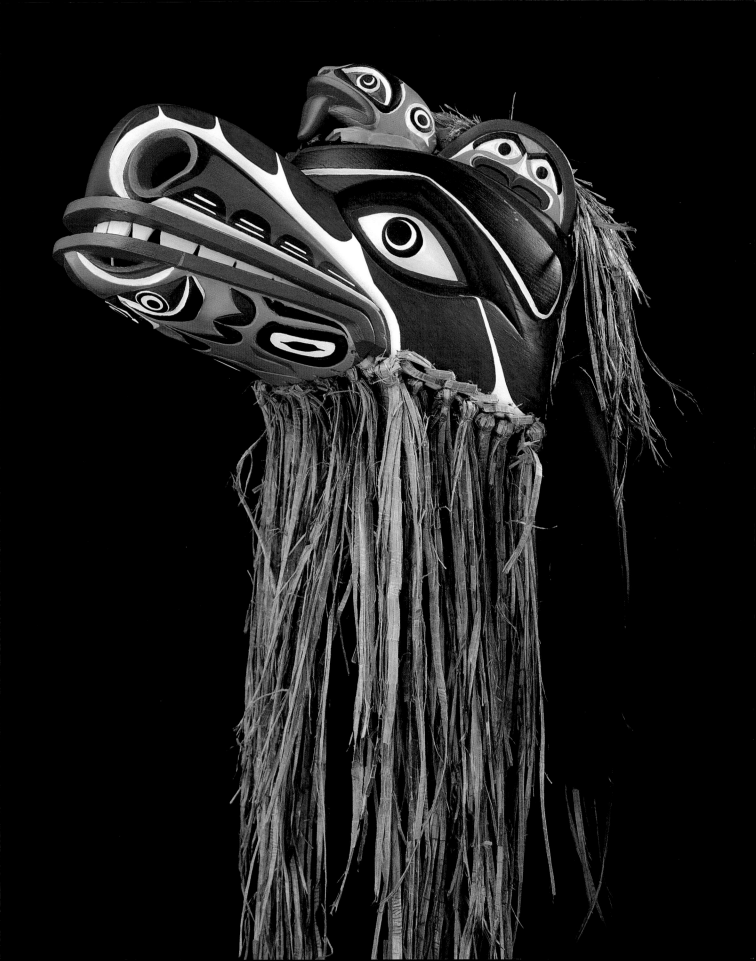

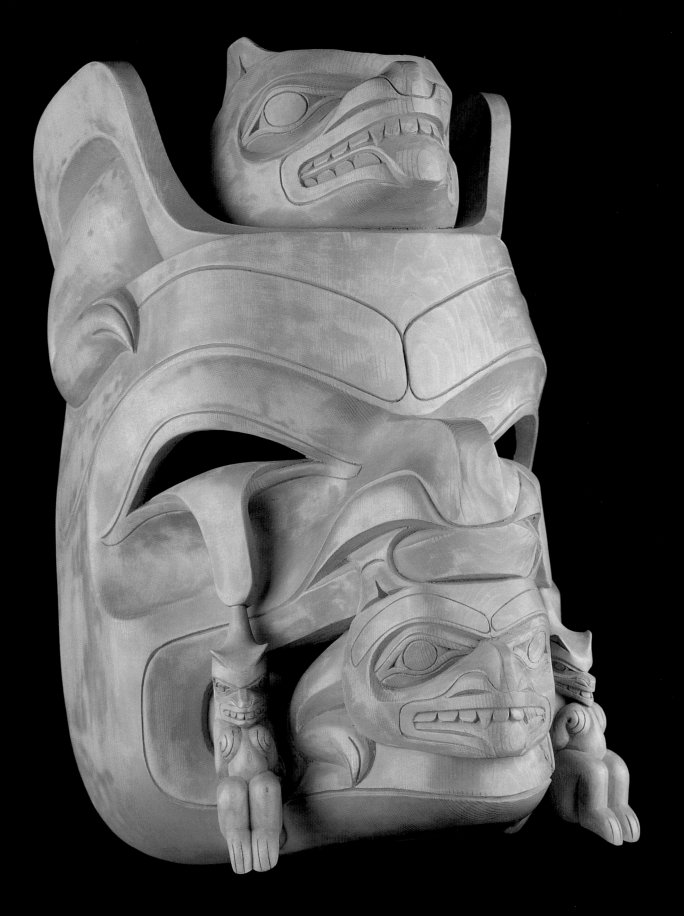

WEEPING GRIZZLY BEAR

FRANCIS HORNE: This mask is carved in a northern style, which is a style that I have always admired. The figures dripping from the Grizzly Bear's eyes are associated with the Nisga'a and Haida story of Volcano Woman, among other characters and stories. I have used this motif in numerous pieces. The figure between the ears is a bear cub.

I wanted to make a mask that honoured the grizzly bear and spoke of the plight of the bear. It is currently faced with a dwindling population and habitat and is overhunted to supply exotic medicines. I have been working in this particular wash-style of painting to evoke a look of copper carbonate. Copper is a symbol of great wealth and power on the Northwest Coast.

Weeping Grizzly Bear

Francis Horne
Coast Salish / Northern style
red cedar, paint
17 × 10 × 10½ inches

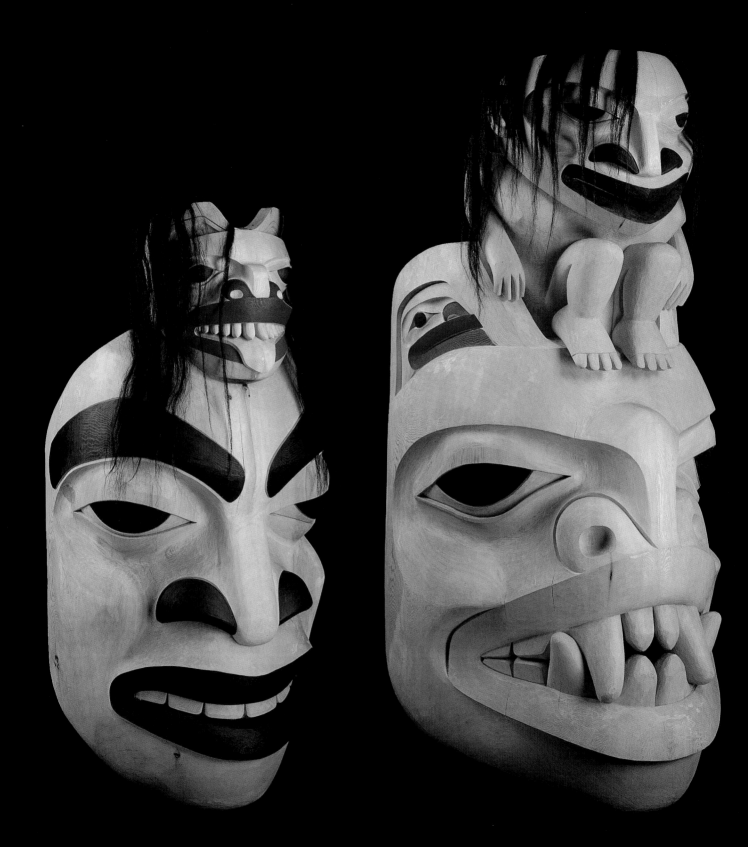

THE LAND

DEMPSEY BOB: These two large-scale masks were commissioned by the Vancouver International Airport as part of a three-artist collaboration (with Robert Davidson and Richard Hunt) to represent the land, sky and water in a collective installation. My pieces are the land, so I chose to depict a bear as it is representative of the land and the forests of the Northwest Coast. Whatever happens to the environment affects the bear. This fact is crucial to our understanding of the present and future approach to our forests and the creatures that live there.

The Bear is part of my crest, and part of the responsibilities associated with a crest is the care and preservation of the environment within the crest's domain. When I was young, my family would fish in Salmon Creek near the Stikine River along with the bears—black, brown and grizzly. At night, my grandmother would go into the forest and speak to the bears in our language and no harm ever came to us.

Two Masks

Dempsey Bob
Tahltan / Tlingit

left
Human-Bear
red cedar, horsehair, paint
5 feet × 30 inches

right
Bear-Human
red cedar, horsehair, paint
7 × 3 feet

THE WOLF

JOE DAVID: This Wolf headdress was carved specifically to be worn at the 1991 David family potlatch held at the Tin Wis Cultural Centre near Tofino on Vancouver Island. This potlatch celebrated the adoption of Haida artist Robert Davidson. It was a reciprocal adoption, ten years after I was ceremonially adopted by the Davidson family at the potlatch titled "Children of the Good People," documented in the book *A Haida Potlatch* by Ulli Steltzer.

I carved the headdress in the Haida style to honour Robert Davidson. The creature I chose for it is a Wolf, because the Wolf Society is the major Nuu-chah-nulth secret society. The Wolf headdress is attached to the understanding of spiritual layers, energy layers, historical layers and family names. This is why the adoption process took ten years to plan and implement. Robert was given a serious and important name within our family.

Wolf Headdress

Joe David
Clayoquot (Nuu-chah-nulth)
red cedar, abalone shell, operculum shell, wolf pelt,
ermine pelt, feathers, leather, paint
10 × 14 × 8 inches

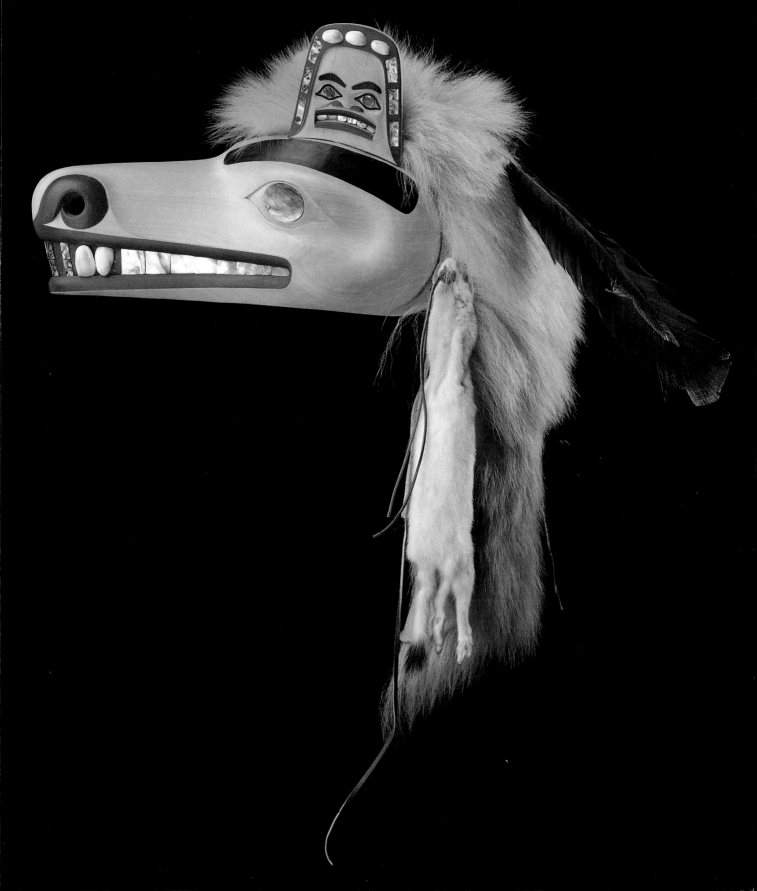

WOLF TRANSFORMATION

The Wolf transformation headdresses were carved for Robert Martin Sr., Nuuk-Miis, House of I'-Wass'aht, Tla-o-qui-aht. The following statement is by his son, Ron Martin:

"The ceremonial regalia that belongs to my family personify many things including our roots, property, history, beliefs, teachings, our spirit, our strength etc., apart from their elegant and artistic qualities. These treasures are brought out during sacred ceremonies and occasions. They are not meant for public display. The rules that govern the showing of them are in accordance with strict custom and tradition.

"My father, Bob Martin Sr., acquired the rights to these masks from his father, George Martin, who owned four transformation masks like these ones by Tsa-qwa-supp, although it is not known what happened to the original masks.

"Four songs and two Wolf transformation masks were inherited from our great, great-grandfather from Oo-tsoos-aht. The human portrait recalls our great, great-grandfather in Oo-tsoos-aht owning forty Wolves, and their ability to transform into Killer-whales after crawling into the ocean, the human faces

representing their blowholes. The transformation is synchronized with the drumbeat and words in the song. The human faces also represent our great-grandfathers being carried by these Wolves/Killerwhales. They are his source of authority as a chief, or his foundation. The masks also remind us where we are from, the house where forty wolves were carved into the centre beam, which recalls the name of the chief's wife and her role within the house. The masks recall our teachings to not only do what is right but to have the compassion to do what is appropriate.

"We keep these traditions alive to prepare our children for life and their continued well-being. Thus in March 1993, the rights to use these masks were given to Courtney Martin, Bob's grand-daughter.

"These masks are a real source of pride for our family. They embody many things including the original masks from Chicklesaht and Oo-tsoos-aht, our history, our property, spirituality, belief system, relationship ties, names, dignity and respect for ourselves and for others, an understanding of who we are and where we are from. These are the values that kept us strong in the past and will help us survive in the future. Our family will always be thankful and honoured by Tsa-qwa-supp for carving these masks."

BIRTH OF THE DITIDAHT PEOPLE

TSA-QWA-SUPP (ART THOMPSON): I felt it was important for the occasion of a book on the state of the contemporary art form that these headdresses by shown as they would be seen, with a drum. The drum depicts the birth of the Ditidaht people from the Raven. The design was chosen as the logo of the International Aboriginal Games held in Victoria in 1997.

Headdresses and Drum

Tsa-qwa-supp (Art Thompson)
Ditidaht (Nuu-chah-nulth)

Hinkeetsum
(Wolf Transformation Headdresses)
red cedar, cedar bark, feathers, horsehair, paint
each 20 × 16 × 8 inches

Birth of the Ditidaht People Drum
animal hide, red cedar, paint
diameter 20 inches

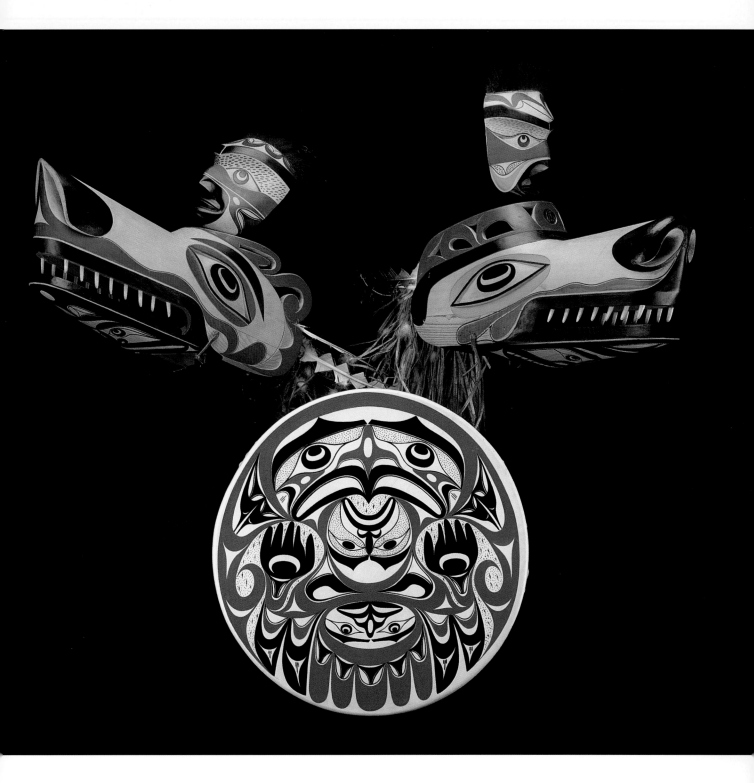

THE MORTAL WORLD

THE FROG

DON SVANVIK: In the story told by this mask, giant frogs are said to have lived on the coast hundreds of years ago. Even at that time they were rare and to even see one would bring luck and success in any endeavour. If you stored the frog's fat with your treasure, the treasure would be doubled.

In this story, a hunter-warrior kills a giant Frog and discovers four shield-shaped coppers beneath it. He then obtains all the privileges associated with these coppers.

Another story also tells about the wealth and transformational abilities of the Frog. A man has just been refused marriage to the chief's daughter by the chief. The village is in the midst of famine, and the man leaves to forage and hunt in the forest. He encounters a supernatural Frog, who lends him his skin. This allows the man to understand the ways of the animals, and he hunts freely. He returns to the village with the food and becomes quite wealthy. Then he goes again into the forest, puts on the frog skin and further explores the wealth of the forest, returning with more food and treasures. He becomes greedy and continues to extract more and more from the forest and the frog world, but each time the frog skin becomes harder to remove. Finally, on one visit, he puts on the frog skin and permanently transforms into a frog.

I used copper for the eyes and an articulated tongue to signify the wealth associated with the Frog. Four frogs and four tadpoles are depicted in this mask, which demonstrates the supernatural ability of the Frog.

Frog Headdress

Don Svanvik
’Namgis (Kwakwaka’wakw)
red cedar, cedar bark, copper, abalone shell, paint
29 × 23 × 13 inches

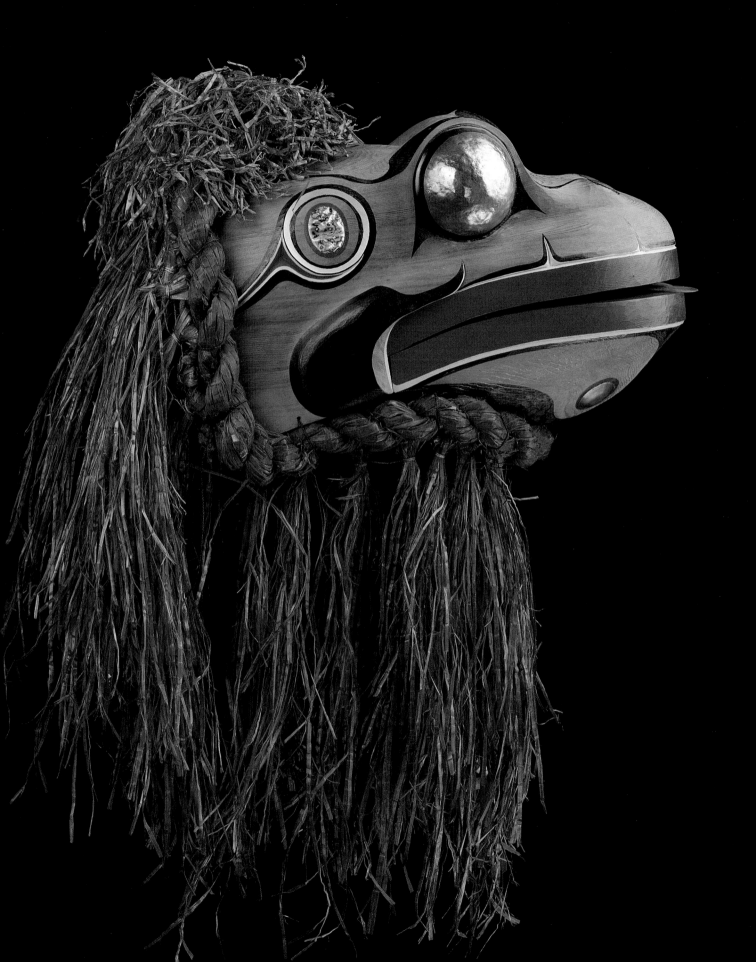

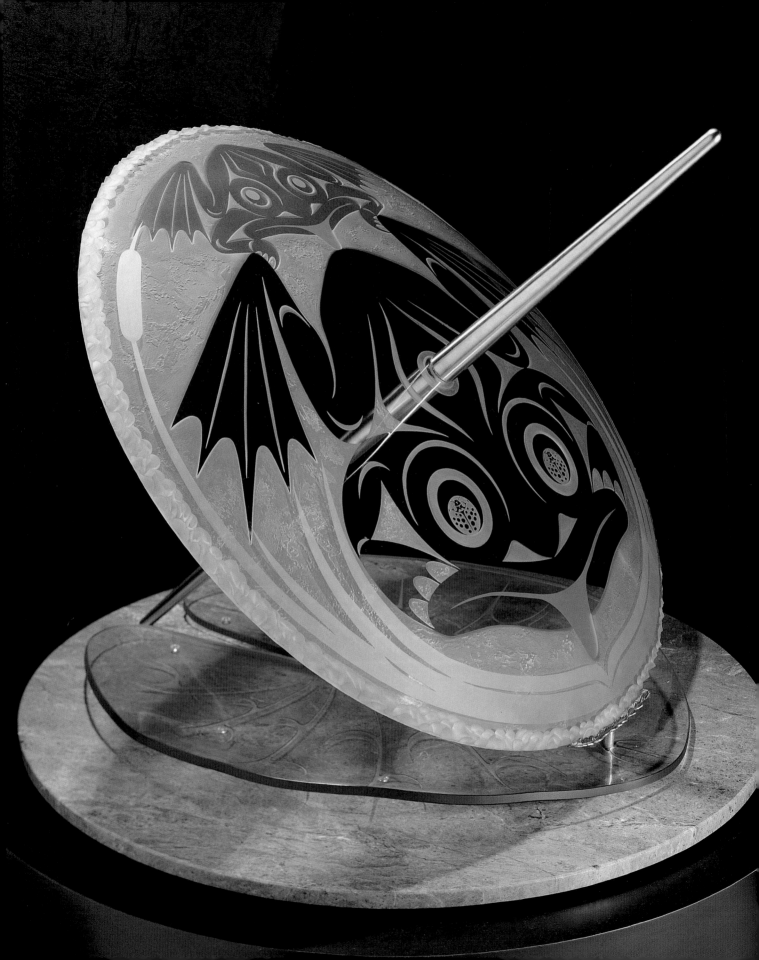

FROG AND LADYBUG

SUSAN POINT: Rather than simply depicting a particular animal like a frog, I thought it would be more interesting and playful to have the frog actually doing something or to have something happening within the piece.

It is a coincidence that I used a ladybug—or maybe not. It just so happened that I was in my garden, and a ladybug landed on me. I put it in a jar so I could study it with a magnifying glass. This led to the incorporation of the ladybug in the frog's eyes and the lily pad, a combination of two-dimensional and three-dimensional design that was very much what I was addressing in creating this sculpture. I tried to extend the two-dimensional design from the surface of the whorl by incorporating the lily pad.

The ladybug is attracted to its own beauty and sees its reflection in the eyes of the frog. Also, remember that if the ladybug escapes from the first frog, there is a second frog waiting for it.

The title is left up to the interpretation of the viewer: "What do you think—imagine you're a ladybug."

Imagine You Are a Ladybug
(spindle whorl design)*

Susan Point
Coast Salish
carved and slumped glass, granite, stainless steel
diameter 36 inches

* see note about spindle whorl on page 18

83

FROG AND THE VOLCANO WOMAN STORY

LIONEL SAMUELS: In Haida mythology, the Frog is known as the spirit helper, or the liaison between the land, the water and the spirit world of the deep forest. The Frog has knowledge of each world.

This Frog bowl is intended to collect rainwater with which to purify and renew the spirit. The Frog also protects the water held by the bowl. Water is one of the earth's most sacred treasures, and the Frog is the guardian of all earth's treasures. The Frog also sings the song that brings rain to replenish the earth.

On the bowl, two Frogs are touching tongues to symbolize their communication with one another. Frog medicine teaches us to honour the element of water and the East (the world beyond Haida Gwaii, and the people and the power that lie in the outside world).

The Frog is also part of the Volcano Woman story. The Frog is trying to get to the river but three boys keep throwing it back into the forest. The Frog keeps trying, but after several attempts, the boys throw the Frog into a fire they have made.

The Volcano Woman senses that one of the forest's children has been killed, and she demands that the village punish the boys for this violation of the balance of nature. The villagers consider the Volcano Woman as a madwoman who is talking nonsense. One young woman believes her and leaves the village, taking her only son with her.

Soon after, the mountain erupts and destroys the entire village. The young woman travels through the now barren world until she reaches the sea. She finds a canoe and travels to the mainland, where she meets the Nisg̱a'a people and marries one of them. When her Haida son reaches adulthood, he chooses to return to Haida Gwaii.

Frog Bowl

Lionel Samuels
Haida
argillite*
4 × 8 × 6½ inches

* Argillite is a grey-black, shalelike soft stone that is indigenous to Haida Gwaii and nearby region. Traditionally, argillite was carved to make objects for shaman and for ceremonial purposes. In the postcontact period, buyers encouraged artists to merge Haida sensibilities with European ideas to produce objects such as bowls, boxes, pipes, jewellery and model totem poles. The Haida word for argillite is *hlgal7agaa*.

THE MORTAL WORLD

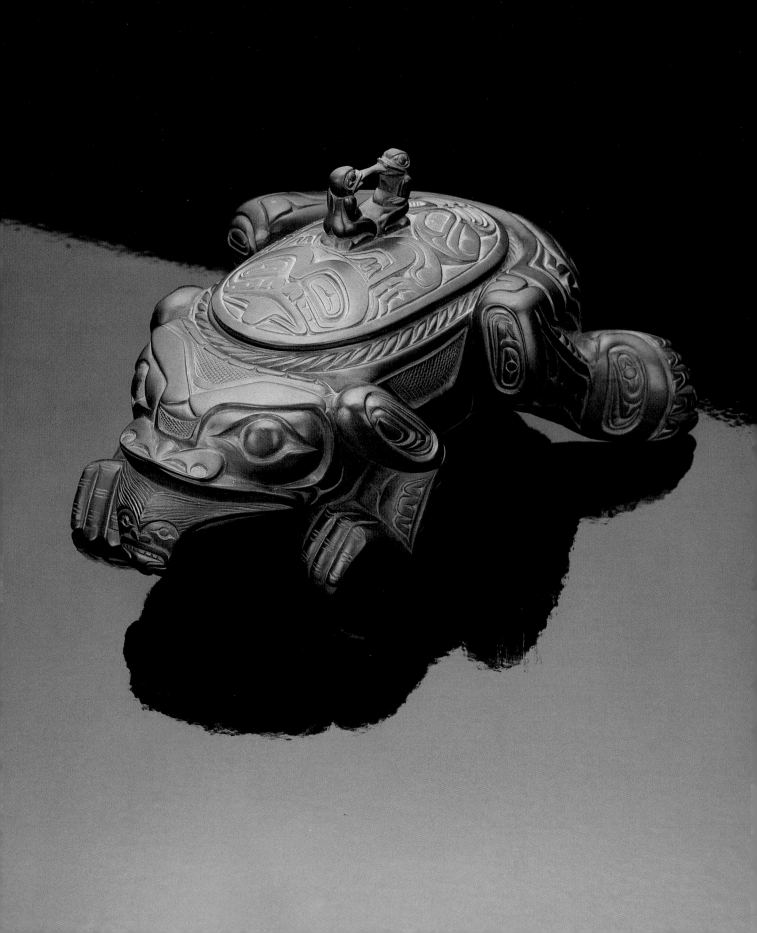

BEAVER BRACELET

LYLE WILSON: The Beaver was my birth crest in the matrilineal clan system of the Haisla, in which children belong to the mother's clan. I was, however, adopted into my father's Eagle Clan, because a large number of Eagle people had died. I regard my ties to the Beaver Clan as unbreakable!

The wild beaver is a symbol of industriousness. This animal is always damming streams and building dens. It uses its incisor teeth to cut down trees and chew off the branches—which it mud-mortars together for building materials. The beaver uses its distinctive tail to slap the water to warn of danger and to balance itself while chewing down trees. Both the teeth and tail are distinct symbols of the Beaver in our traditional art. There is a Haisla proverb that says: "If you work hard today, you will have plenty tomorrow."

Precontact carvers used a chisel with a beaver-tooth blade, so the beaver has played an important part in our wood-carving traditions. I've tried a tooth knife on yellow cedar, alder and yew wood pieces—woods that are progressively harder—and this ancient tool produced yeoman results.

In this bracelet, I tried to fuse the metal, art and history to the spirit of the Beaver. Standard engraving on metal is usually glaringly reflective because it is highly polished. This piece has many surface textures to highlight and focus attention on the carving, rather than the metal. To enhance the depth, I carved out the background areas before cross-hatching them. The hatching differs from the cross-hatching by breaking up the surface of the metal in a linear fashion. Some anatomical details are modeled to modify the light reflection. The stippled texture activates the surface and softly diffuses the reflected light. Some details are left highly polished to give a sense of the gleaming gold surface. The result is a miniature, subtle, bas-relief carving of a Beaver masquerading as a bracelet.

Beaver Bracelet

Lyle Wilson
Haisla
18-carat gold
width 1½ inches

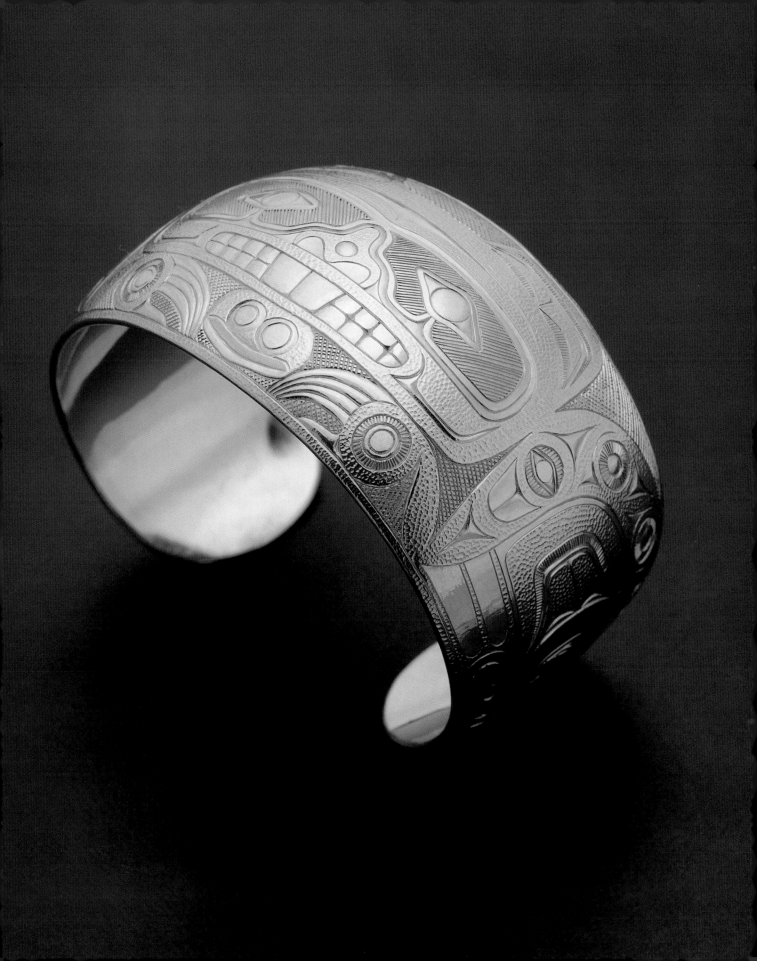

THE BEAR MOTHER STORY

RON RUSS: The Bear Mother story is a core myth of the Haida people. A young woman of noble status is picking berries when she steps in bear dung and loudly curses the Bear. A handsome stranger appears and takes her to a large forest village, where he reveals himself to be a Bear. In time, they marry and have two half-human, half-bear cubs. The woman is of the Raven Clan, as is the Bear. So, much more than being a story about marriage between species, it is about the taboo of marrying into your own clan. The telling of this story reinforces the strict clan system of the Haida.

On the pole, the top Bear figure holds a Frog, which is a subcrest of the Eagle Clan. This cross-clan reference on a Raven Clan totem pole is a respectful reminder of the rules of marriage. The bottom figure is a Bear holding a human and is flanked by the two bear cubs.

The top three figures are known as the Watchmen, and they represent the three brothers of the missing woman. They are sent in turn to look for their sister—a search which lasts for several years. The youngest of these brothers finally encounters the two half-human cubs alone in the forest. He recognizes them as not only being part human but as having attributes of his lost sister. He takes them back to the village, and their fate becomes the subject of heated debate. The chief allows the brother, who is their immediate guardian, to make the final decision. He decides to free them in the forest, in the hope that they will lead him to their mother.

The Bear father has spent this time in a frantic search for his cubs. When he sees them in the forest being led by the human, he sees him as a threat to his family and immediately attacks. The young man is an experienced hunter and kills the Bear. He then releases the cubs and follows them to the Bear village. He sees his sister and presents her with the pelt of her husband. As her brother and the slayer of the husband, he demands her return, and he again leads the cubs with their mother back to her family's village.

A second tribunal is held, and this time a decision is made to kill the cubs. The younger brother challenges the decision, and before the execution can take place, he sneaks them and their mother to a canoe and sets sail for the mainland.

Bear Mother Totem Pole

Ron Russ
Haida
argillite*
height 14 inches

* see note about argillite on page 84

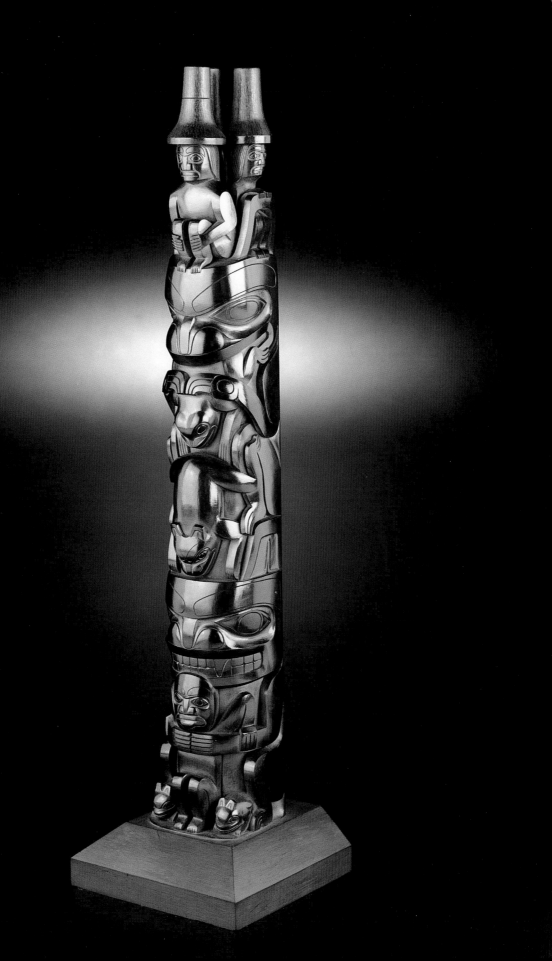

TWO INSTITUTIONS, TWO SOCIETIES

CHUCK HEIT: This chief's seat was carved for the show "Topographies: Aspects of Recent British Columbia Art" at the Vancouver Art Gallery. The figures on this chair are designed to show how the political structure of a Gitxsan family compares with that of a museum. The large central figure shows a Chief transforming into an Eagle. This Eagle is the Chief's spirit power (*naxnox*). This is the Head Chief of the family. The big boss. When this figure is thought of regarding a museum, U will see it as the Director of the museum. The big boss. On each side of the Director are Guardian figures, museum security staff there to guard the treasures. A Gitxsan family has Warriors to keep the families and their possessions safe. Each Warrior/Guardian has a dagger for a tongue, and these figures are in the shape of coppers, which were of immense value in past times.

On each side of the chair is a disk with a large face in the middle. They are the Wing Chiefs. Every Gitxsan family has 2 Wing Chiefs. They work closely with the Head Man and together make all the important decisions. They compare well with the roles that museum Trustees play. All the tiny faces surrounding the Trustees/Wing Chiefs represent the rest of the Gitxsan family and the rest of the museum staff. All of them are considered eligible to move up the ladders of power in their respective organizations.

The figures all along the edges of the chair show the world. The Chief and family are surrounded and shaped by the world. On the top edge of the central part of the chair U can see the sun; the moon is shown once on each side of the sun, and next are some stars. These celestial bodies are riding on a rainbow. These heavenly bodies have kept all the societies of the world in awe and wonder.

Near the top corners is the Raven, the Trickster. The Gitxsan call him Weegyet, and we regard him as a great teacher. Just like a museum. He has many different names and faces throughout the world. Some call him Coyote or Nanabush.

On the bottom of the chair are a female and a male, the foundation of every society. They are U and me, everybody, the beneficiaries of these two great institutions. They are surrounded by the icons of their societies.

Chief's Seat
below and on facing page (detail)

Chuck Heit
Gitxsan
mahogany
33½ × 71 × 25½ inches

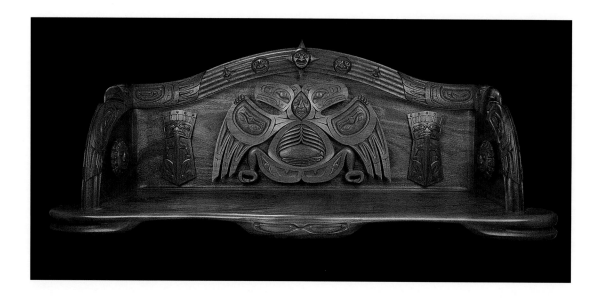

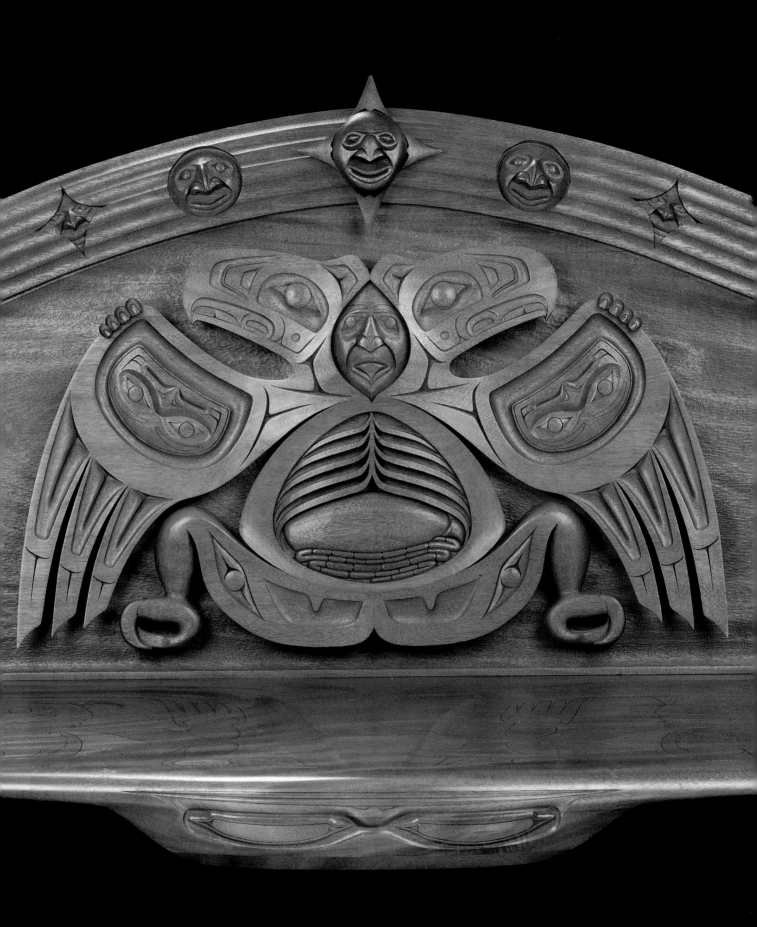

BENTWOOD BOXES

LARRY ROSSO: Bentwood boxes were made only by peoples of the Pacific Northwest Coast. The boxes were used for storage, cooking and to safeguard ceremonial objects when not in use. Like all utilitarian objects, they were elaborately designed and painted with the crest symbols of the owner.

In the 1960s, I learned the art of bending boxes from Doug Cranmer, who had relearned these techniques and taught other artists. He also was a valued teacher on box design, something that takes years to develop. I am still learning today. The size and shape of the box dictates much of the design.

The canoe-style box or tackle box (facing page, left) has odd angles because it is meant to be wedged into the prow of a canoe. If the canoe capsized, the fishing gear in the box would not be lost. The lid can be lifted only partially, a feature that further protected fishing gear from loss. The box also could be used to store fish. This box has an Eagle design on the front, with its wings on the sides, and tail feathers and claws on the back.

The largest box (facing page, centre) has two crest symbols. The first is the dominant Eagle design, with the sub-crest of the Bear fitted into the Eagle's wings and tail in the back. Boxes like this one were prominently displayed in the ceremonial hall as clan references and to hold ceremonial objects.

The medium-size box (facing page, right) is a very modern design. I wanted to take some of the fine elements of traditional boxes and place them inside the "U" shapes that wrap around the four sides. The lid is an extension and expression of the "U" shapes that I love working with.

The bulge-wood style of making bentwood boxes requires working with a thick plank of wood that is thinned and kerfed at the intervals where the corners are to be. The plank is then steamed: traditionally, this was done over shallow trenches in the dirt filled with hot rocks, water and a seaweed cushion to protect the wood. When the plank is softened by steam, it is bent at each kerf to form the sides of the box. The bottom is attached using pegs.

The Eagle bulge-wood box (this page) is based on a particularly large one in a museum. I was given the challenge of making a larger version and redesigning the motifs. I consider the bulge-wood form to be the ultimate in box craftsmanship, both in design and sculpture. On the front is the Beaver, a symbol of wealth, which is reinforced by inlays of abalone, another symbol of wealth. The Beaver is depicted in a semihuman form on the back side, with elements of both Beaver and human on the sides. To enhance this piece, the lid is in the form of Eagle wrapping itself over the bulging box. This was rarely done with old boxes.

Four Bentwood Boxes

Larry Rosso
Carrier

on this page
Eagle Bulge-wood Box
red cedar, abalone shell, paint
16 × 15 × 28 inches

on facing page, left
Canoe-style Box, Eagle Design
red cedar, leather, paint
12 × 11½ × 13 inches

on facing page, centre
Eagle Bear Design Box
red cedar, paint
28 × 20 × 19½ inches

on facing page, right
U-form Design Box
red cedar, paint
17 × 13 × 13 inches

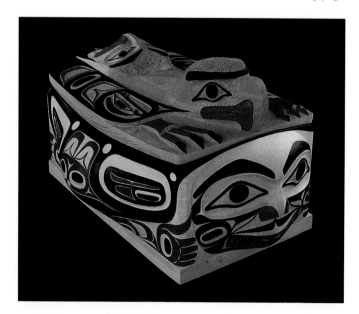

92

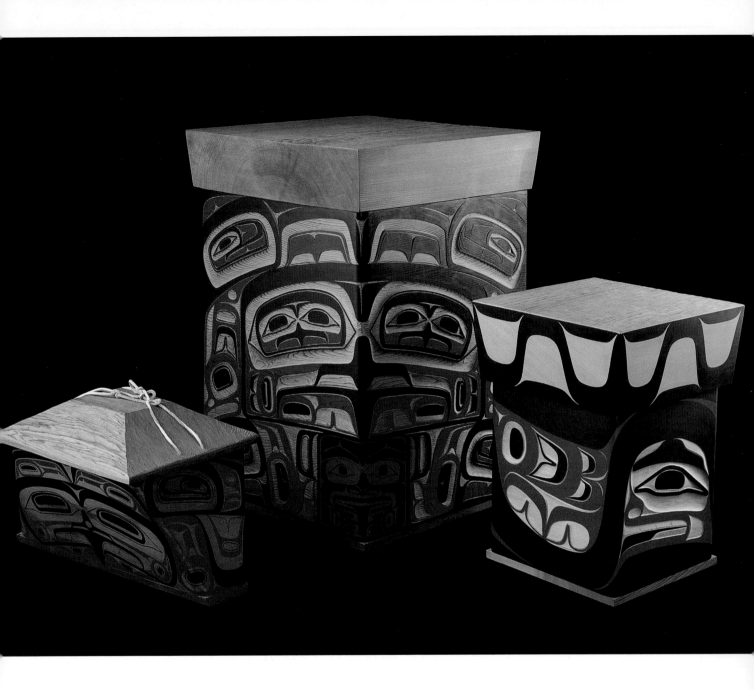

THE MORTAL WORLD

ROADBLOCK WARRIOR

CHUCK HEIT: This roadblock warrior is getting flaming MAD. Look at him with your own conscience: is he mad at U?

I started road-blocking by direct orders from my chiefs of KISPIOX. At the roadblocks u get 2 meet lots of misinformed people. I believe they act dumb because in Canada the full truth of history is not told. Some of these people tell us 2 get off the road and back 2 the reserve where we belong (we hold all our Kispiox roadblocks in the middle of Kispiox Indian Reservation #1). A lot of the visitors r unpleasant people who seem 2 not like anyone who is not white. I am glad 2 tell u that we get some friendly visitors who r looking 4 the truth about British Columbia and Confederation. 2 bad they are the minority. The majority of whites r very mad at us. They like 2 threaten young and old alike. Some Gitxsan people from Kispiox r also like that! Experiencing roadblocks makes me think that Canada might tie itself into a knot if some tribe sat at the barricade with guns. What if they got MAD? . . . What if? Well, now we all know Canada got stupid enough 2 get the Mohawk Warriors mad. They called up over 5000 soldiers and police 2 try cleansing itself. Army, Navy, Air Force, SQ, RCMP, OPP, Satellites, U.S. advisors, spies, dogs, and other idiots. Why????? Just to satisfy some town fools??????

Note: Over the past few years, business interests—particularly resource-based ones such as logging, fishing, mining and recreational development—have challenged the constitutional rights and principles held by Native people. The idea of the roadblock is to blockade an access road and staff it with people to interrupt travel and sometimes to stop resource extraction, as well as to educate observers about the issues related to the dispute. The roadblock is intended to be a nonviolent political and educational action, but some have escalated into larger conflicts. The artist refers to one of these, the 78-day standoff that took place at Kanehsatà:ke near Oka in eastern Canada—with Native people placed under siege by the forces of the Sûreté de Québec (SQ), the Ontario Provincial Police (OPP) and the Canadian army.

Angry Man—Roadblock Warrior

Chuck Heit
Gitxsan
silver birch, paint
13 × 13 × 9 inches

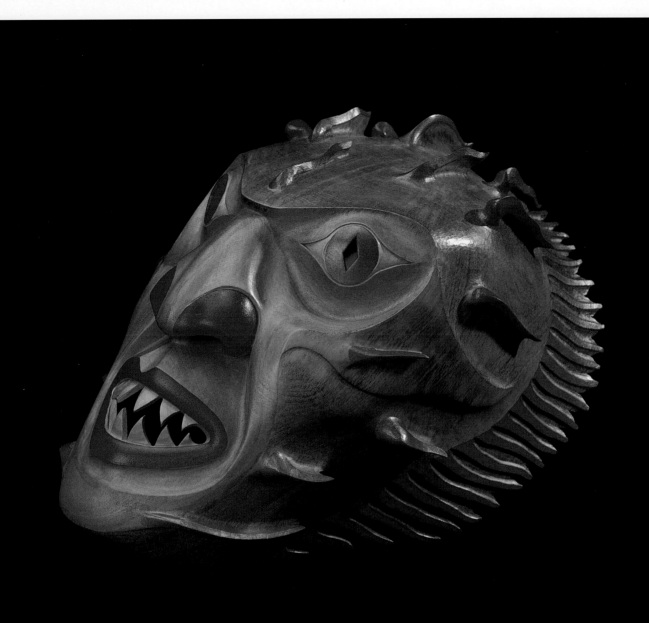

THE MORTAL WORLD

KLUKWAN YADI

CHERYL SAMUEL: This robe represents a journey into the past and the future. It is the first time that Chilkat and Ravenstail weaving techniques have been incorporated into a single work. The title *Klukwan Yadi* means "the grandchild of Klukwan." Klukwan translates as "the place that has always been there" and is known as the Mother Village of the Chilkat. Many weavers came from this village, giving the name Chilkat to their ceremonial robes and the techniques used to weave them. I was adopted into the Strong family of Klukwan, Kaagwaantaan (Eagle Wolf), and given the name Saantaas ("the one who puts the warp on the loom"). Saantaas was a very fine Chilkat weaver from the mid-1800s, and I feel honoured to share her name with my sister, Lani Strong Hotch.

Klukwan Yadi speaks of the past, of holding tight to the tradition of the Chilkat weavers. My knowledge comes from the old robes, the ones held in museum storage rooms. I spent many years learning the techniques by studying the work of these weavers: first Chilkat, then the older style, now called Ravenstail.

Klukwan Yadi also speaks of the future, of taking the knowledge and skills that I have acquired and allowing them to express something new. In designing it, I used the traditional Chilkat black and yellow borders to define the robe. Inside these is a Ravenstail border; along the top is the pattern known as Ancestors, which has been rearranged to become Houses of the Ancestors. The Ravenstail side border uses a pattern called Tree Reflections. The bottom border is a new design which I call Fast River. I think of the two corners of the robe as the eddies of the current as the river changes direction. This is where the rectangular Ravenstail shape is pushed into the five-sided Chilkat format. Inside the borders is a skip stitch pattern I call Four Corners.

The Salmon and Eagle appliquéd onto the woven robe is designed by Tsa-qwa-supp. It is based on the Nuu-chah-nulth story of wealth and plenty, where the Salmon grow so large and abundant that the Eagles have trouble lifting them from the water. I was excited that he chose this design, as the village of Klukwan is also famous for the thousands of eagles which gather there for the late salmon run.

This robe is also about collaboration with another artist. By working together, we incorporate northern weaving techniques with the most southern tribal design, uniting the entire coast in both style and possibility.

The appliqué technique comes from the button blanket tradition, one that does not involve weaving. Button blankets are ceremonial robes, developed from the historical introduction by European traders of the Hudson's Bay Company blanket and from European sailors who wore brightly decorated coats covered with buttons.

Klukwan Yadi took more than a year of intensive weaving, during which I shared its progress with new weavers who are learning the techniques. My hope is that this robe, an example of tradition and innovation, serves as an inspiration to future weavers.

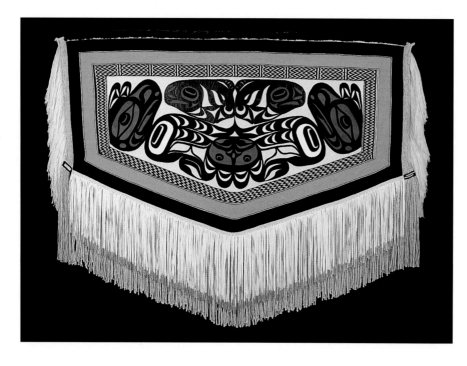

Klukwan Yadi
(Child of the Village That Was Always There)
on this page and facing page (detail)

**Cheryl Samuel and
Tsa-qwa-supp (Art Thompson)**
Tlingit / Ditidaht (Nuu-chah-nulth)
merino wool, cedar bark, leather appliqué and fringes,
beaver fur, tin cones
34 x 62 inches

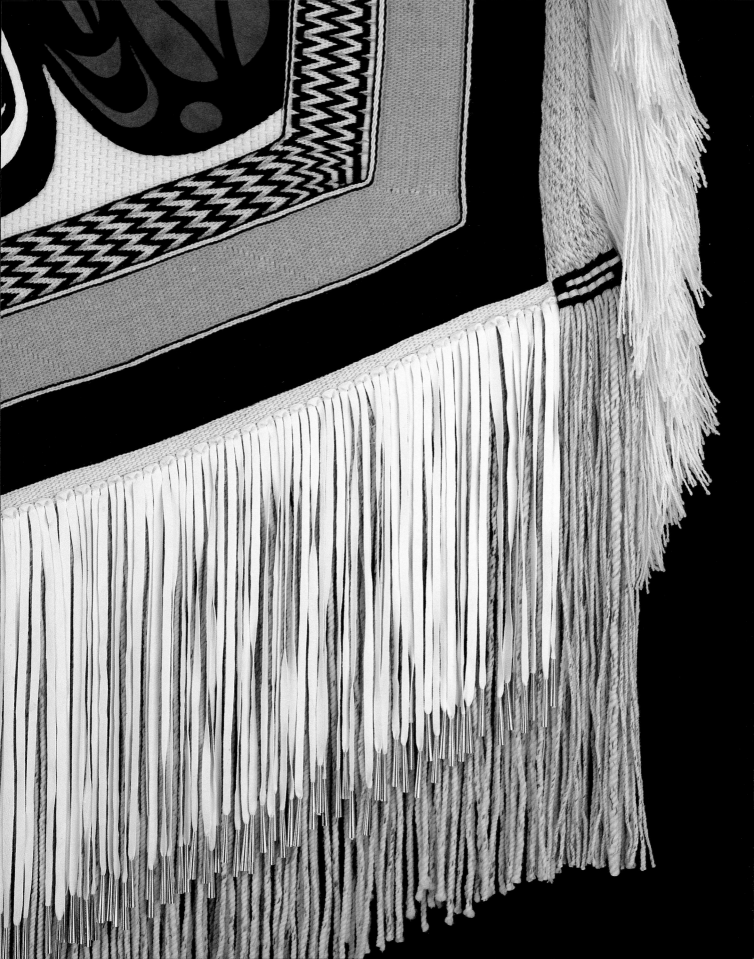

RACCOON

WAYNE ALFRED: The Raccoon is universally known as a thief or bandit, and this is true in stories of the Kwakwa̲ka'wakw as well. It is also known as the animal that can see with its hands.

The Raccoon as part of the animal kingdom dance originates from Gilford Island. After an argument with her husband, a woman of noble birth goes for a long walk. As she strolls on the beach, a Ba̲kwas (wild man of the forest) creeps up behind her and startles her. He tells her of a cave up in the mountains, where all the animals live. She decides to search out this cave. She meets a mouse and, using goat tallow as a lure, coaxes it to lead her to the cave. She enters the cave and catches the animals in their human forms.

The animal chief (the Porcupine) says that she must stay and watch them dance, learn the songs and bring them back to the Gilford people to dance at potlatches.

Raccoon

Wayne Alfred
Kwakwa̲ka'wakw
red cedar, cedar bark, paint
13 × 12½ × 9 inches

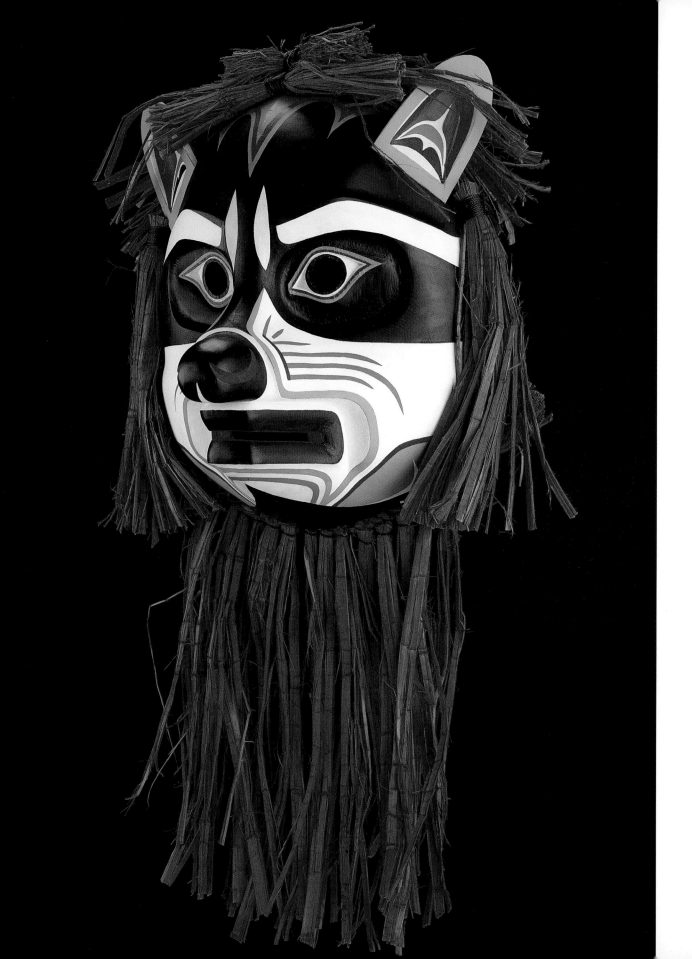

THE
UNDERSEA
WORLD

CHIEF OF THE UNDERSEA WORLD

DON SVANVIK: Ḱumugwe', the chief of the undersea world, lives in a great house with live sea lions as house posts. His powers include the ability to see into the future, heal the sick or injured and bestow privileges to whomever he wishes. His treasures include blankets, coppers, songs and dances. If you are able to enter the realm of Ḱumugwe', you may learn the ways of the undersea world and return home with many magical treasures.

The mask displays an octopus, who is a servant of Ḱumugwe' and the gatekeeper to his realm. The loon is often displayed atop Ḱumugwe' as a reference to his great size: the loon mistook him for an island and landed on his head. On the chest of the loon is the figure of a person who has been to the world of Ḱumugwe' and returned with treasures—one of them being this mask.

The Kwakwaka'wakw have elaborate dances representing the undersea world, the animal kingdom and the sky world. Each shows the real and supernatural creatures of these domains, and the special powers and attributes that they have. These stories are linked to historical discoveries and events that earned families the rights to display these beings as crests and to dance their stories.

Ḱumugwe'

Don Svanvik
'Namgis (Kwakwaka'wakw)
red cedar, cedar bark, paint
18 × 10 × 18 inches

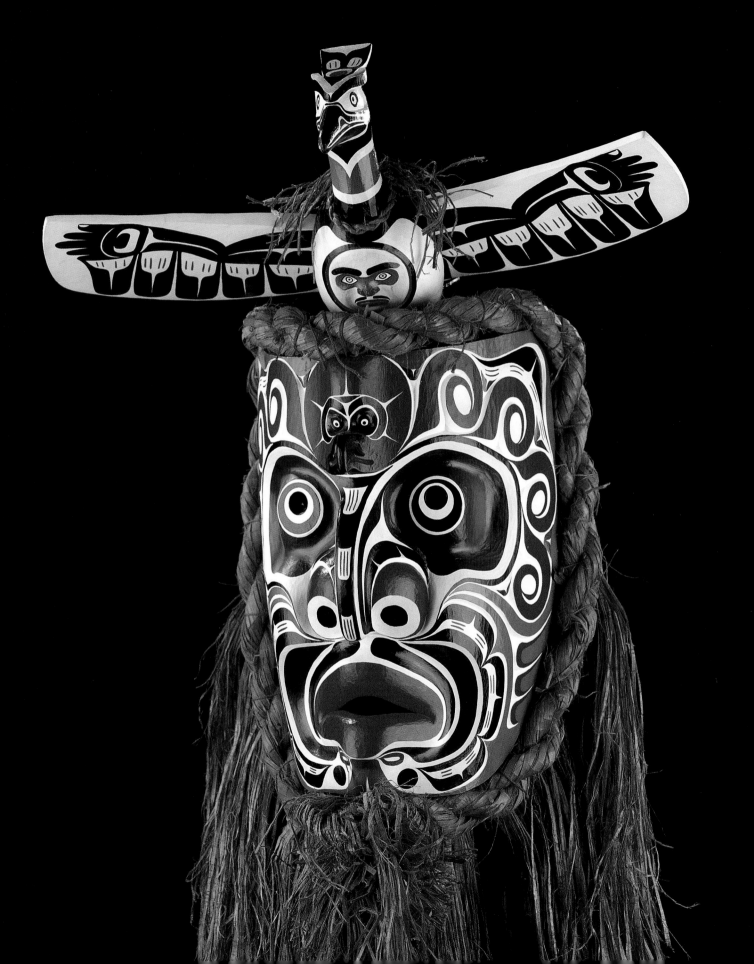

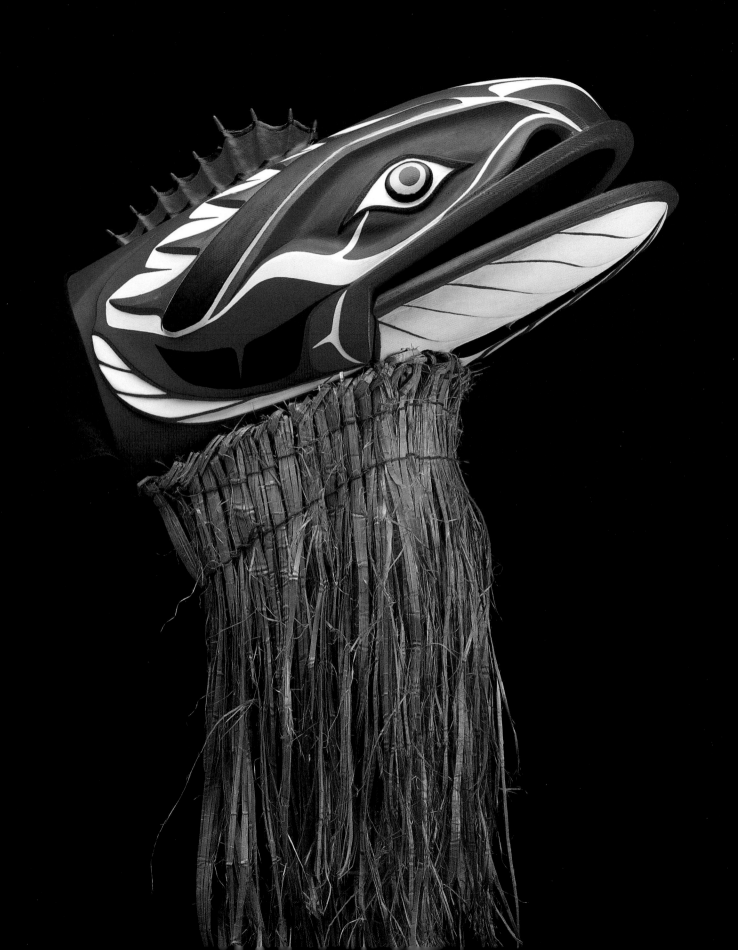

THE LING COD

GLENN TALLIO: The ling cod was an important food resource for the Nuxalk people. During the fall ceremonial season, creatures that were important food sources were honoured in a series of dances that was related to the respect for the balance and preservation of nature, and a celebration to thank the great spirit for the gift of food. The Ling Cod headdress is not about a single idea or story but one that is interconnected to a much larger series of dances and events.

Ling Cod Headdress

Glenn Tallio
Nuxalk
red cedar, cedar bark, cloth, paint
12 × 10 × 22 inches

THE SWIMMERS

LYLE WILSON: Jewellery is an established tradition within Northwest Coast art and illustrates the adaptability of the art to new materials. To our ancestors, the earliest precious materials were bone, stone, abalone shell and ivory. These materials were carved into the amulets, talismans and adornments that laid the foundation for a jewellery tradition. Native-discovered copper was the traditional precious metal, but silver and gold were introduced by Europeans. Most contemporary jewellery pieces are now made of silver and gold. Modern artists are much like their ancestral counterparts, generally open to new ideas and materials.

The salmon, which is greatly valued as our major food resource, was celebrated throughout the Northwest Coast in the art, ceremony and song. The Haisla people even have a Fish Clan. My grandparents often told of the time the salmon were so abundant that you could walk across a river on the backs of spawning salmon without getting your feet wet. Comparing our ancestors' respect for the salmon to our current prosaic values as mere food and commodity indicates the need for reassessment. Many of the salmon's natal streams, rivers and lakes have been compromised by human activities. Now there are mere remnants of precontact fish stocks, yet they remain an awesome natural spectacle as they fight upstream in order to spawn future generations.

I considered all of my experiences with salmon before I started this jewellery piece. They are beautiful creatures, from their youth as cute little fry to the silver brightness of the adult ocean traveller. Even the spawned-out carcasses dying in shallow waters are beautiful when you know that before death comes, they start the foundation for future salmon by laying and fertilizing their eggs.

In this combination brooch and pendant, I carved a male and female salmon in bas-relief, then engraved wavy lines to suggest a watery background. The rim is also bas-relief, a rope that connects to a hook. The lure is based on the hunting instincts of the feeding salmon. In the gloom of the water, the salmon will strike at a flashing, moving object, mistaking it for a small silvery fish. In one respect, we share the salmon's like of bright objects, but in our case it is fine jewellery. In theory, the initial "flash" is the large gold disk which attracts our eye. We then "school" with the two salmon before the spiralling rope "plays" us to the centre, where we are "hooked" by the diamond lure.

The Swimmers

Lyle Wilson
Haisla
22-carat gold, diamond
diameter 2 inches

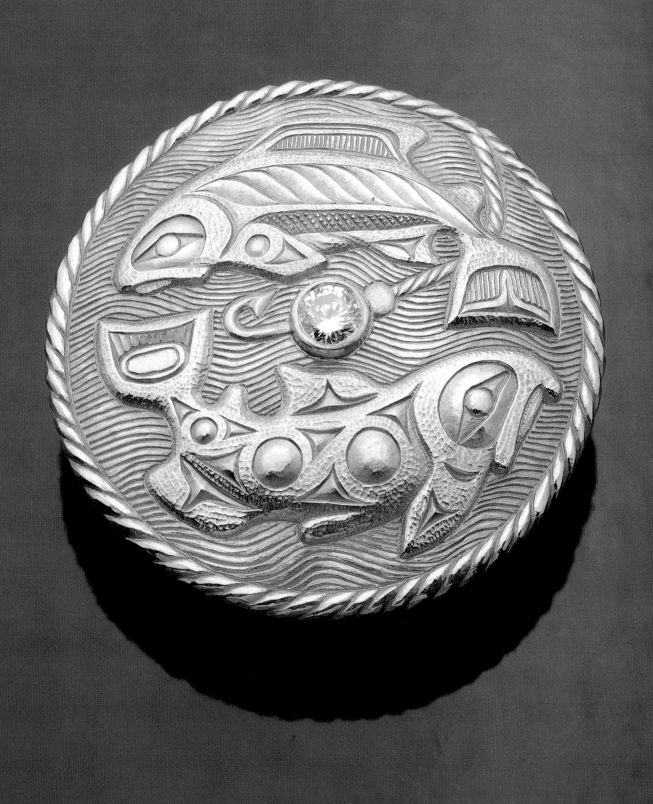

THE HEART OF ALL SALMON

NORMAN TAIT: The title of the sculpture in Nisga'a is *Got's Gaam Luulak*, which means "heart of all salmon returning upstream."

A salmon made from a single block of alder moves upstream, leaping over a maple burl. The salmon represents all of those overcoming obstacles to return upstream to their birthplace. On reaching home, the salmon discards the old life—its spirit enters a new body and is reborn.

Inside the fish's ribcage is a small man who is the spirit driver, guiding the salmon and steering it on its journey. The man represents the spirit of all salmon, a spirit that never dies. Intricately carved scales inlaid with abalone shell shimmer like light hitting water and fish. The heart, drive and spirit of all salmon struggling to return home are embodied in this figure of a man inside the ribcage.

Along the sides are ovoid faces carved in walnut. Starting at the tail, the first face represents Trout Head, the spirit of new life. Next is Spirit Face, shown in profile, portraying all the ancestors. Under the dorsal fin, Salmon Head symbolizes maturity. Human Face represents the people, the guardians who ensure that the earth's riches are not overused or wasted. Behind each ovoid face is a hidden cavity, a spirit box within the salmon. These cavities contain personal objects that are important to those who commissioned the sculpture and that have become part of the spirit force of the sculpture.

Got's Gaam Luulak

Norman Tait and Lucinda Turner
Nisga'a
alder, maple, walnut, abalone shell, horsehair, paint
36 × 36 × 48 inches

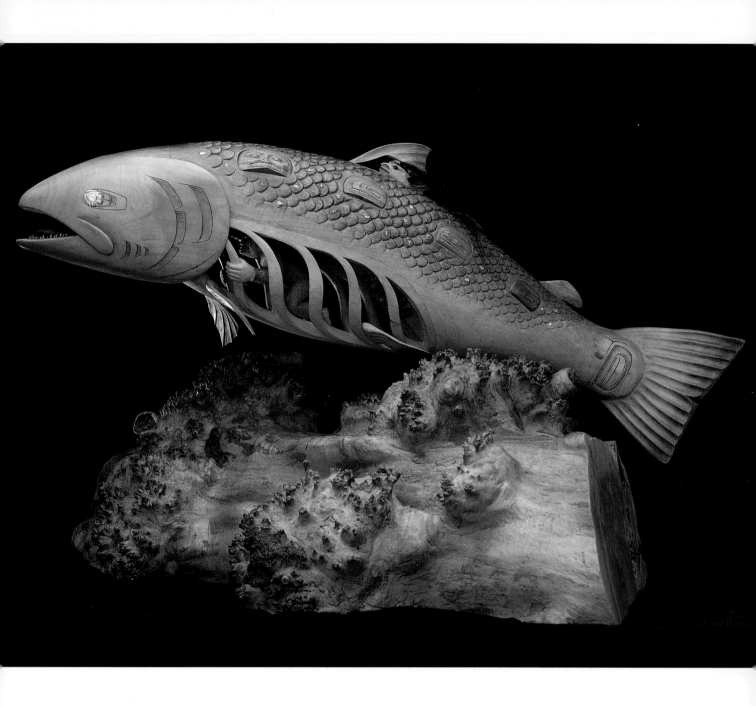

THE UNDERSEA WORLD

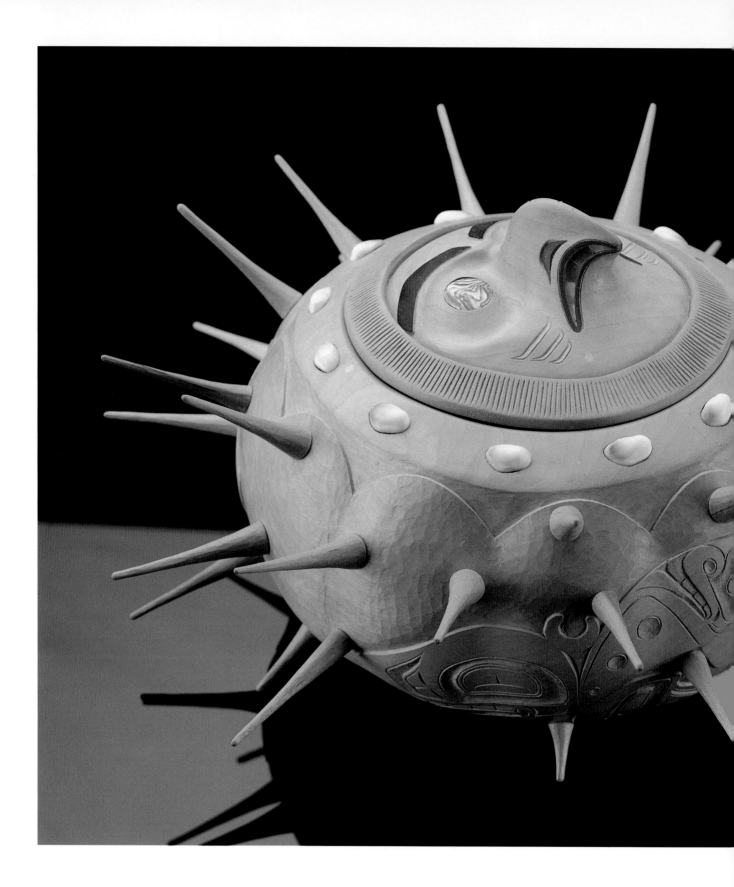

THE UNDERSEA WORLD

THE SEA URCHIN

NORMAN TAIT: On the Northwest
Coast, wooden bowls were considered
prestigious gifts, which then became
objects of daily or ceremonial use.
There is an intimacy between the user
and a well-crafted, hand-held, wooden
bowl that lures the viewer to touch and
explore the details. In carving this bowl,
I attempted to capture this intimacy
with the shape and fine finish—but on
the other hand, the spines prevent this
from happening. This is in the nature of
the Sea Urchin.

 Since my helper spirit is the Killer-
whale, I carved Killerwhale crests
beneath the spines.

 The lid depicts the spirit of the Sea
Urchin and is inlaid with different kinds
of shell from its world: operculum, pearl
and abalone.

Sea Urchin Bowl

Norman Tait and Lucinda Turner
Nisg̱a'a
alder, operculum shell, abalone shell, pearl shell, paint
13 × 9 × 13 inches

111

RAVEN STEALS BEAVER LAKE

CHRISTIAN WHITE: The story "Raven Steals Beaver Lake" is one of many in which Raven travels throughout Haida Gwaii in various disguises, looking for food and treasures to steal. These disguises were necessary because of Raven's reputation as a meddler and Trickster, so he could not move about freely in his own form. But he had the ability to transform into other creatures, and this allowed him to visit those whom he had already deceived. One of the Raven's favourite victims was the Beaver (Ts'ing), who was known for his great wealth.

Raven often visited Beaver's village to see what was new. He transformed into a young man to insure that he was respectfully received by the Beaver. The youth was invited to the Beaver's great longhouse and was cordially entertained. The Raven-in-disguise was pleased with the attention and the delicious food, which was well beyond his expectations of the Beaver, who was more concerned with labour and industry than with fine food.

At the rear of Beaver's lodge was a carved screen. The Beaver told the youth to look away while he moved the screen to one side. Raven looked away but he had a slate mirror that he dipped in water and, in the reflection, he saw the Beaver fish out a salmon, which was a new creature to the world. The salmon was also the source of the wonderful food that was being offered.

A messenger arrived to request that the Beaver chief attend to an urgent matter in the village. The Beaver chief excused himself and invited the young man to feel at home but requested that he not venture behind the screen at the back of the house.

Immediately after Beaver left the lodge, Raven transformed back into bird form and went to see this great new creature living in the lake. Raven pondered catching one of these big fish, but in his greed decided to attempt to steal the entire lake. He rolled the lake up like a huge carpet, so that he could carry it in his beak. As he took flight, the ends of the lake drooped on each side, and the salmon began to spill out, falling into streams and rivers throughout the Northwest Coast.

In this sculpture, the Raven is shown in mid-transformation between Raven and human, sitting on top of the lake. The Beaver is rendered as a crest on the sides of the box.

Raven Steals Beaver Lake

Christian White
Haida
argillite*, abalone shell
10 × 10 × 7½ inches

* see note about argillite on page 84

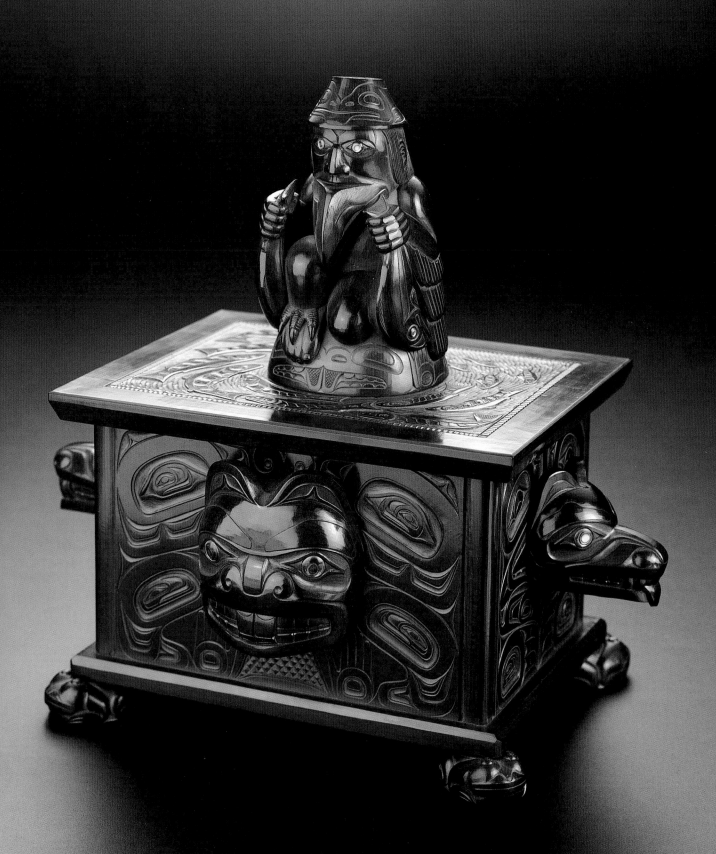

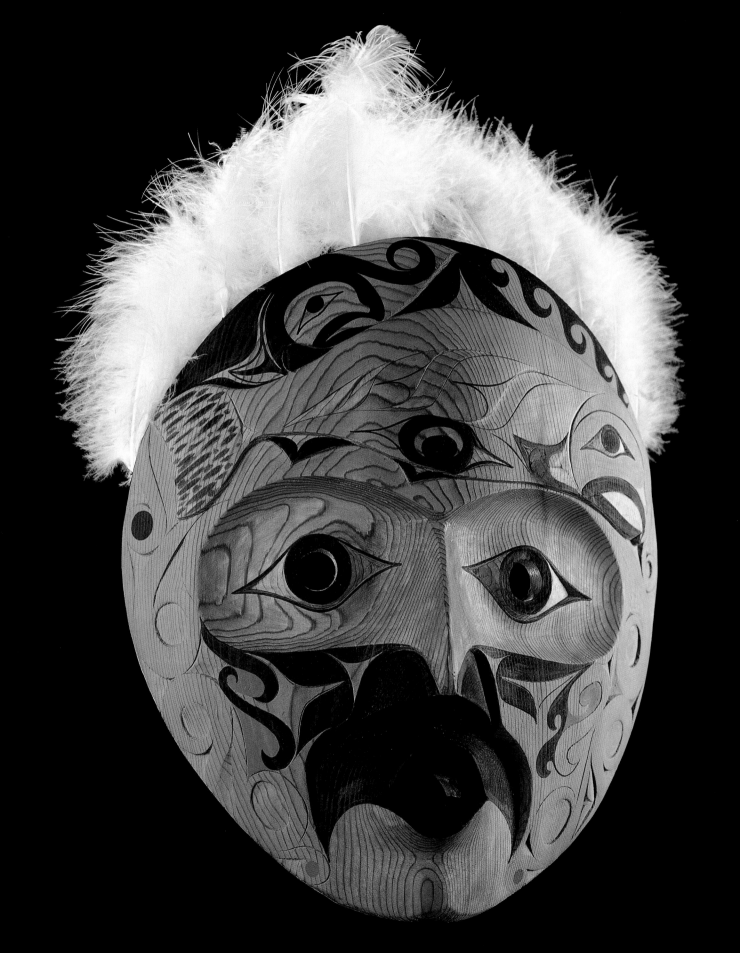

LISTEN TO THE RIVER

TIM PAUL: This mask represents the River inviting you—*"Ha-in-mis"*—to listen to what it is saying—*"Hum-ma hum-ma." "Wa-wa?"*—What am I saying?

I grew up at Esperanza Inlet, north of Tofino, on the west coast of Vancouver Island, where there were three major watersheds that are no longer there due to logging and development. The result is that the salmon no longer have a parent stream. *Cu-uił* (migratory salmon) *cu-ha-cu-ha* (sway back and forth) with no place to go. Salmon must return to their parent stream to spawn and die, continuing the life cycle to insure the next generation of salmon. From this, we know that we must treat nature as our relative.

The Moon is a very powerful symbol for our people, and it is what we use in its growing stage to prepare ourselves. They are one, the Moon, the River and all of nature.

Ca-àk (River) Mask

Tim Paul
Hesquiat (Nuu-chah-nulth)
red cedar, ostrich feathers, paint
14 × 13 × 6 inches

OCTOPUS AND JELLYFISH

JOE DAVID: There is a moment when an experienced designer can draw a few lines that capture a story or creature, and it is fully told. The Jellyfish is small, light, fragile and transparent, and the Octopus is large, dark, opaque and powerful. There is no myth relationship between the Octopus and Jellyfish, except that they are related by shape. When seen together, there is a natural affinity.

Octopus and Jellyfish Drum

Joe David
Clayoquot (Nuu-chah-nulth)
animal hide, red cedar, paint
diameter 30 inches

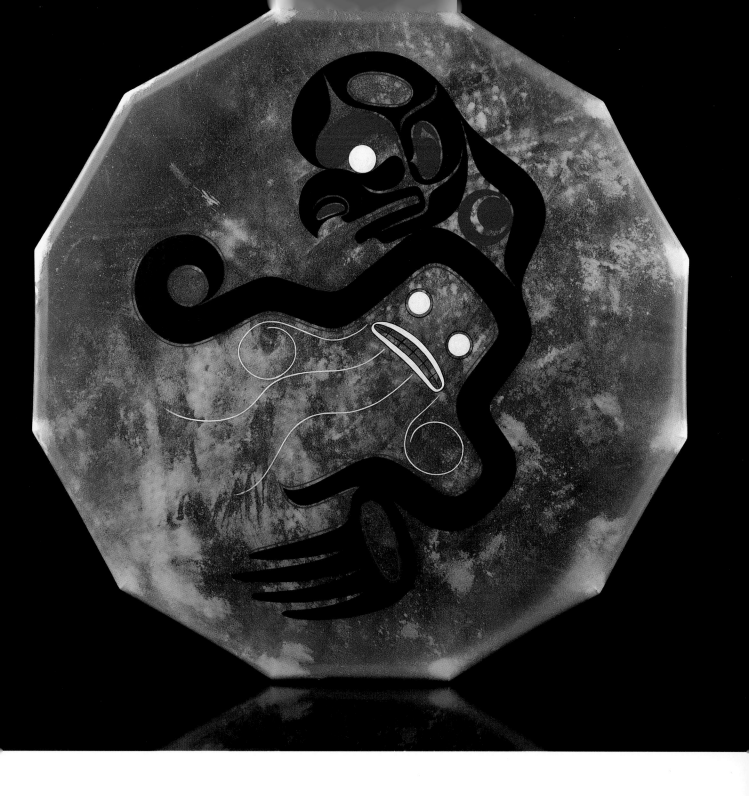

THE UNDERSEA WORLD

KILLERWHALE COMB

LYLE WILSON: Halx̄inix° (pronounced hull-chey-nuach) is what the Haisla people call the killerwhale or orca. Pods of killerwhales roam the coastal waters of the entire Pacific Northwest. Although the orca has many names in different languages, it commands universal respect. The Halx̄inix° is a large, powerful and magnificent creature, and was a natural choice for a clan crest.

The sighting of a killerwhale is a rare and exciting event. I was in a small boat that was in about 15 feet of transparent, green-tinged water in a bay that had a light, sandy bottom—perfect viewing conditions. The orca swam directly towards us; when it was about a hundred feet away, it dove. As it swam beneath our boat, it performed a classic underwater barrel roll. The large killerwhale made me conscious of the puniness of both us and the boat, a feeling my ancestors must have known in their dugout canoes. It was a primordial, spiritual experience that heightened my awareness of the fragile, transitory nature of life and provided insight as well as inspiration for my images of killerwhales. I try to capture and instill the feeling of drama, mystique and wildness of the creature.

In this comb—really a miniature sculpture—I also tried to incorporate the character of yew wood. Yew wood was traditionally known for its density and strength, and many useful implements, such as combs, were made from yew wood. My ancestors also understood the medicinal property of yew wood (its cancer-fighting properties were recently scientifically proven). It was regarded as a special wood.

The yew tree is very slow growing and produces a rich, warm, orange-coloured wood with a dense grain that also can be spectacularly wild. Because every tree is unique, it produces different wood-grain patterns. I've grown to appreciate such differences and now regard them as part of the true character and beauty of the wood. Even the knots can be utilized as part of an artistic effect.

I decided that the Killerwhale would be the main character in this piece. By carving in high relief and undercutting the image, the sculpture becomes more animated and dominant. The abalone inlay accentuates the dominance of the animal. The salmon and seal are prey species of the orca and natural knots are incorporated into their images.

The other side of the comb is more traditional in style, as a homage to past artists. This Killerwhale is more or less a formline carved in shallow relief. There are other aspects to this Killerwhale Comb sculpture, but those are for viewers to discover.

Killerwhale Comb

Lyle Wilson
Haisla
yew wood, abalone shell
6 × 4 inches

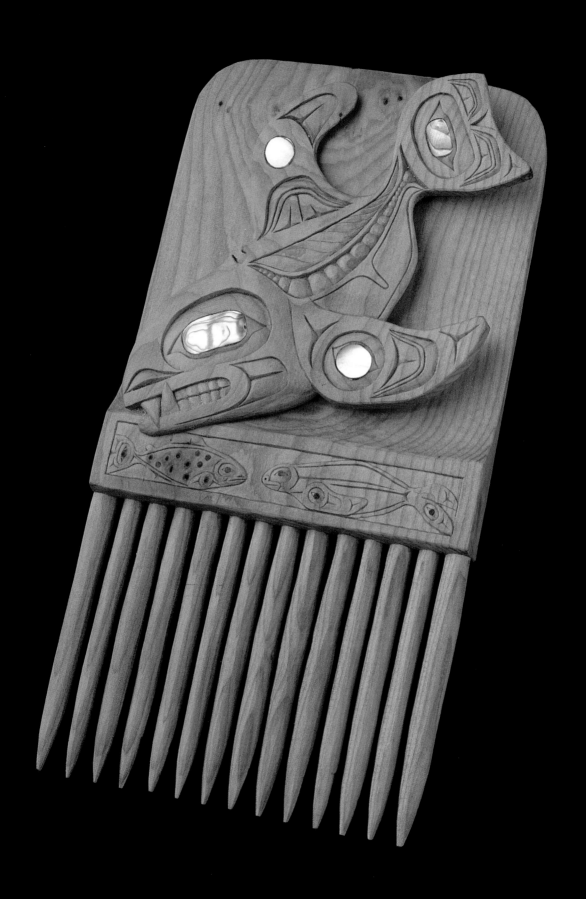

CHIEF'S SEAT

REG DAVIDSON: The chief's seat is the honoured position from which to witness ceremonial events. The wood for this seat came from the same log that I used to carve a 29-foot canoe. I asked Larry Rosso to create the bentwood-style base, which is also a storage space and traditionally used to protect masks and regalia or special gifts that will be distributed to guests following an event. The seat is decorated with the chief's crests, and the one on this seat is the Raven-finned Killerwhale. This crest comes from the story of an important Killerwhale chief, who had a Raven who rode on his fin.

This piece was purchased by a friend and supporter of Northwest Coast art, who has allowed it to be borrowed for special events. One occasion was the wedding of my brother Robert Davidson to Terri-Lynn Williams, in Skidegate in 1996. They chose the same date as his 1969 totem-pole raising in Massett, which was the first totem pole raised in over a hundred years.

This was also the first traditional Haida wedding in over a hundred years, and the entire family from both sides researched all aspects of the event to re-create as much as possible. To have the chief's seat used in various ceremonies is an honour for me as an artist, particularly when it was used as the seat for the married couple, giving me a chance to honour my brother.

Chief's Seat

Reg Davidson
Haida
red cedar, paint
45 × 50 × 30 inches

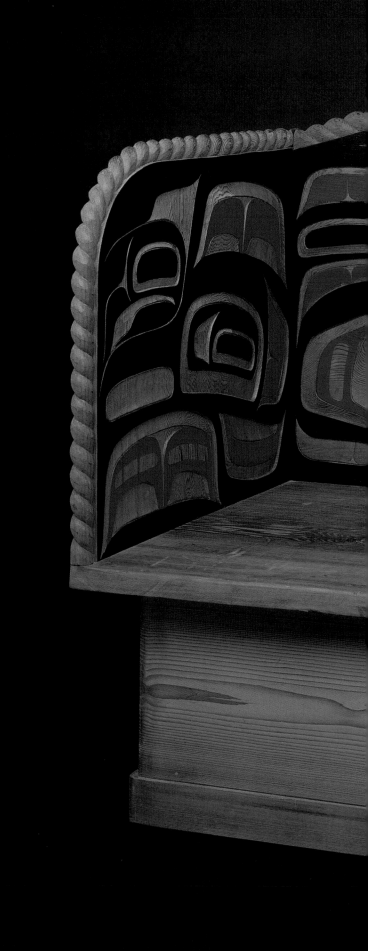

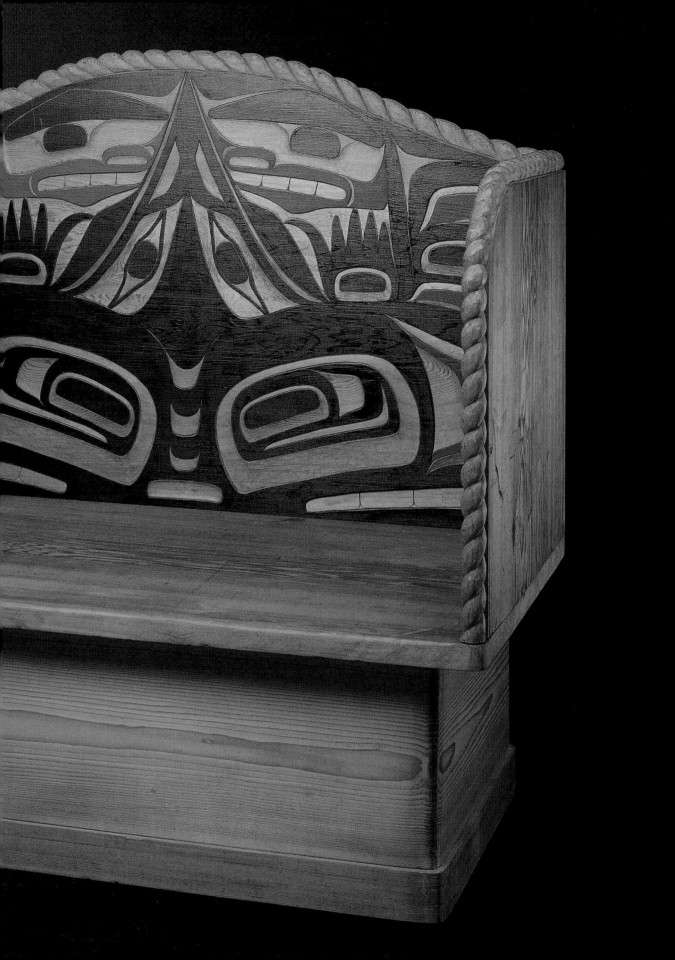

THE
SPIRIT
WORLD

MEDICINE BOWL

NORMAN TAIT: The medicine bowl was the property of the shaman and used by the chief to prepare for battle. The chief would begin by purifying himself in a cleansing ritual and urinate into the bowl over a four-day period. The shaman would then put magic into the bowl by chanting, praying and adding herbs over an additional four days. Just prior to the battle, the chief would anoint himself with the powerful mixture. This would give him strength and invincibility.

Medicine Bowl

Norman Tait and Lucinda Turner
Nisg̱a'a
alder, operculum shell, paint
13 × 11 × 9 inches

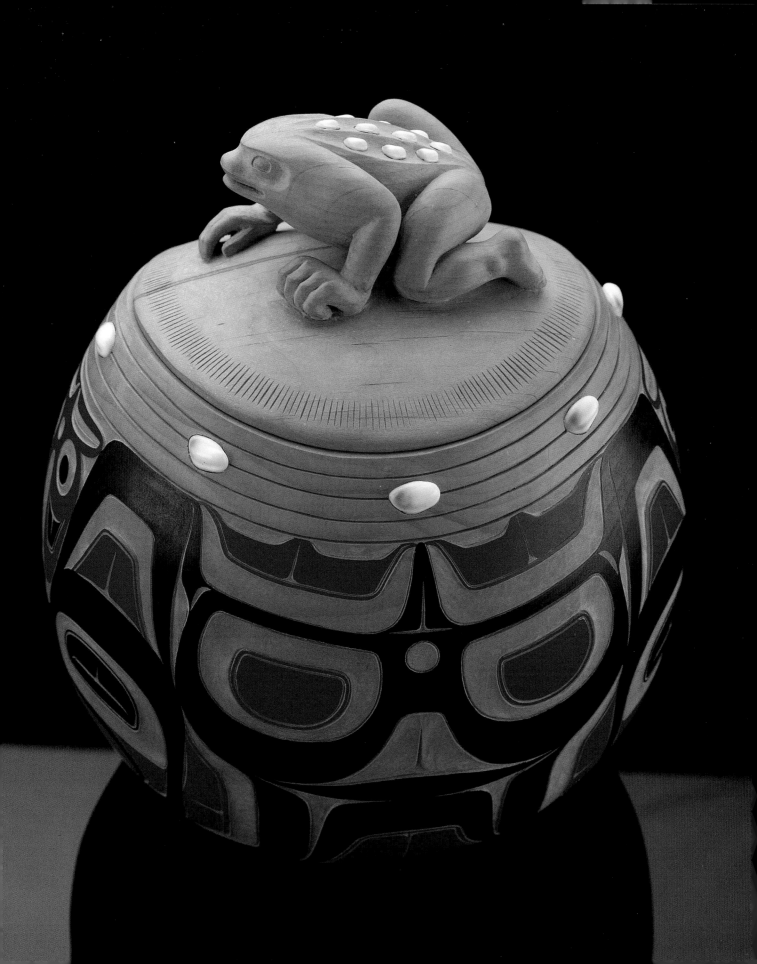

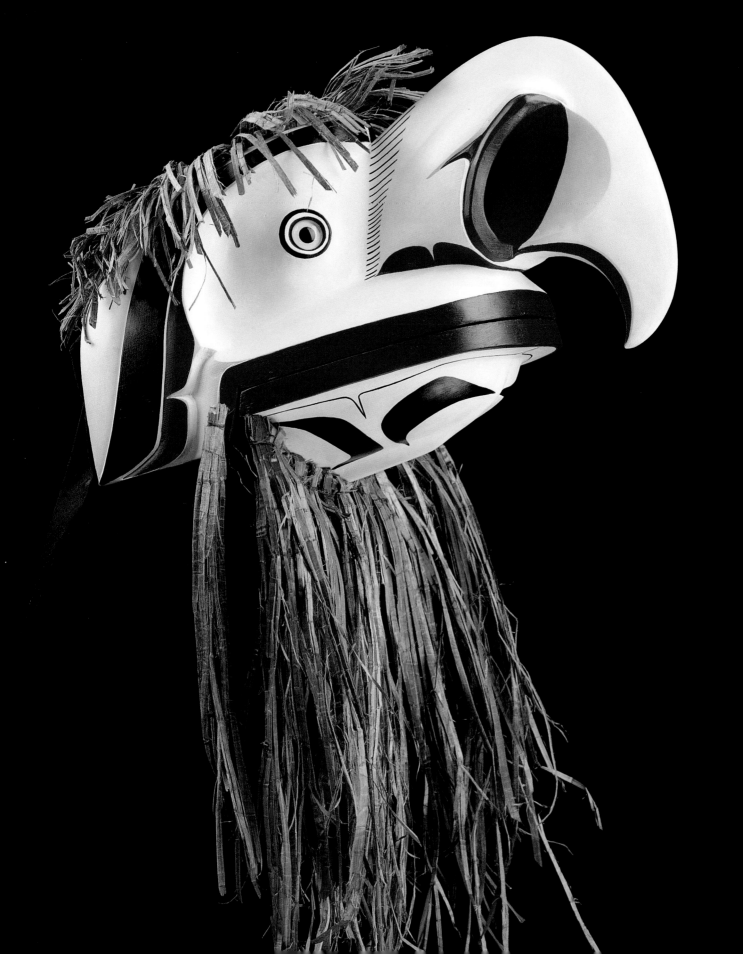

EAGLE INCUBUS

GLENN TALLIO: The Eagle Incubus is not a mask in the traditional sense but a hand-held puppet, operated from under the arm. The origins of this piece may date back to the child attendants who assisted the chief during the Hamaťsa ritual. The scope of the puppet grew to become headdress size.

The term "incubus" refers to the nightmare or dream state, where evil can take control of the situation. The Spirit Eagle would enter the audience and bite people at random. It would then return to the dance floor and, using sleight of hand, appear to regurgitate the partially digested flesh taken from the people in the audience.

One example of the Spirit Eagle in the collection of the Royal British Columbia Museum in Victoria has glass eyes that follow the viewer around the room. I used glass taxidermy eyes to capture a similar effect.

Eagle Incubus

Glenn Tallio
Nuxalk
red cedar, cedar bark, glass eyes, paint, cloth
9 × 17 × 10 inches

GAGIID, THE WILD MAN

ROBERT DAVIDSON: Gagiid is the wild man who has been transformed by the spiritual forces of the ocean. This person has spent time lost at sea or has tipped his canoe but survived the ordeal and managed to struggle ashore in a crazed state. The effects of the spiritual transformation are not immediately obvious. The shivering from the cold, the lack of sleep and food, drive the person towards another level of madness.

The Gagiid is often depicted with sharp spikes around its mouth due to frantically devouring red snapper, sea urchins and other forms of sea life that are covered with spikes (though not in this mask, as that has not yet happened). He lives in caves and, over time, begins to grow a thick coating of hair. He later learns to fly, allowing him to move freely throughout the world, thus eventually coming back into contact with his former human world. People are warned to duck when they see shadows over their heads while in the forest after dark. This is especially real in the time following the loss of someone to the sea.

Northwest Coast art is about transformation, from which there have emerged many strong and definitive characters. There are, however, also many steps in between—as people and animals flow towards a particular form, and from this form to another. Life is a series of many minute changes that continually move towards death and the worlds beyond.

The Gagiid is a fearsome creature, but also someone who can be tamed and returned to a human state. For an artist, this opens many possibilities and allows for the opportunity to interpret different aspects of the being's personality, rather than only a final form.

The first time I carved a Gagiid, I showed it to my grandmother, who commented: "I didn't know that Gagiid was so handsome." It was too nice—not scary enough. Since then, I have carved numerous versions with this in mind, as well as masks such as this one that is about the stages leading up to the frightening form—or possibly the stages that follow when the character has been tamed and is returning to its human form.

Becoming Gagiid

Robert Davidson
Haida
alder, horsehair, paint
13 × 11 × 7 inches

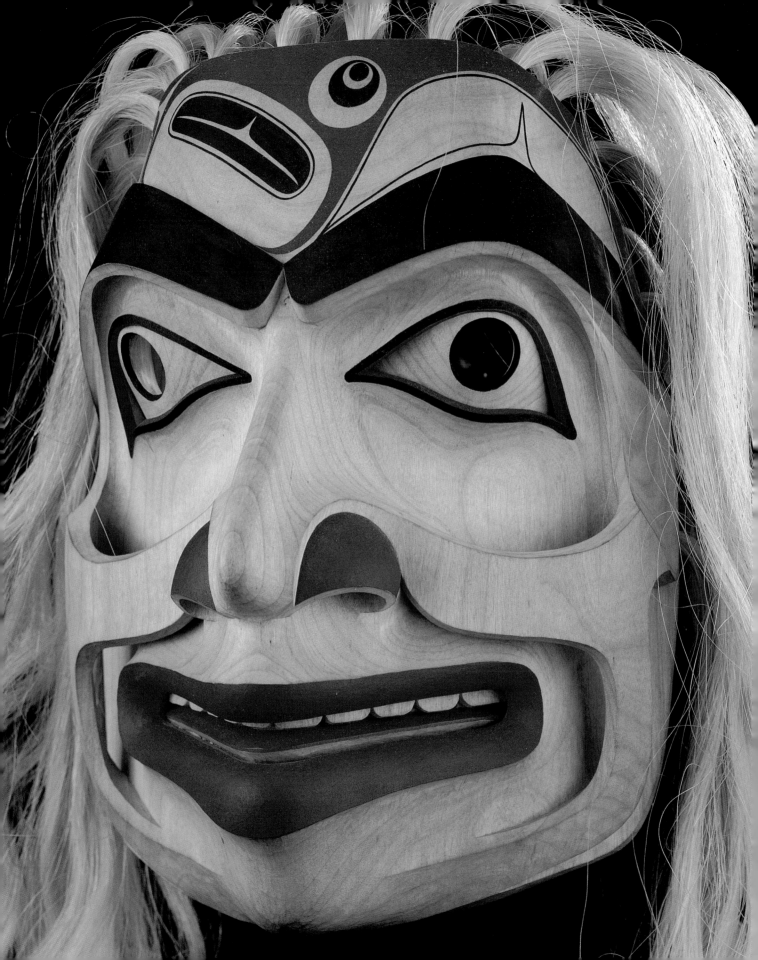

SHAMAN'S RATTLE

Large oval rattles with shallow relief carving were associated with the shaman. Gerry Dudoward made a particular study of rattles and produced numerous variations of Raven or chief's rattles during his career.

This shaman's rattle was among his final pieces. The subject of the shaman's rattle, which symbolizes the line between life and death, and the veil between the human and spirit worlds, intrigued him and influenced his work. Facing a terminal illness did not affect his creativity, and he carved with enthusiasm and skill right up until his death in 1998.

Shaman's Rattle
two views

Gerry Dudoward
Tsimshian
alder, horsehair, cord
10 × 5 × 3 inches

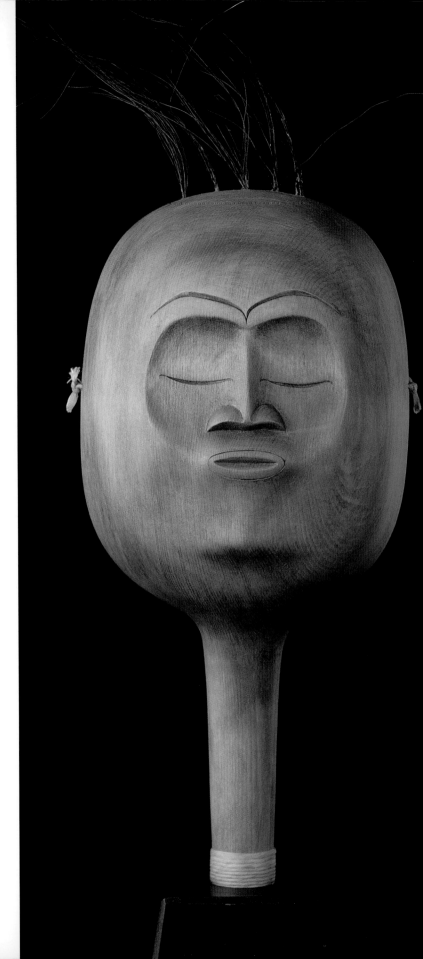

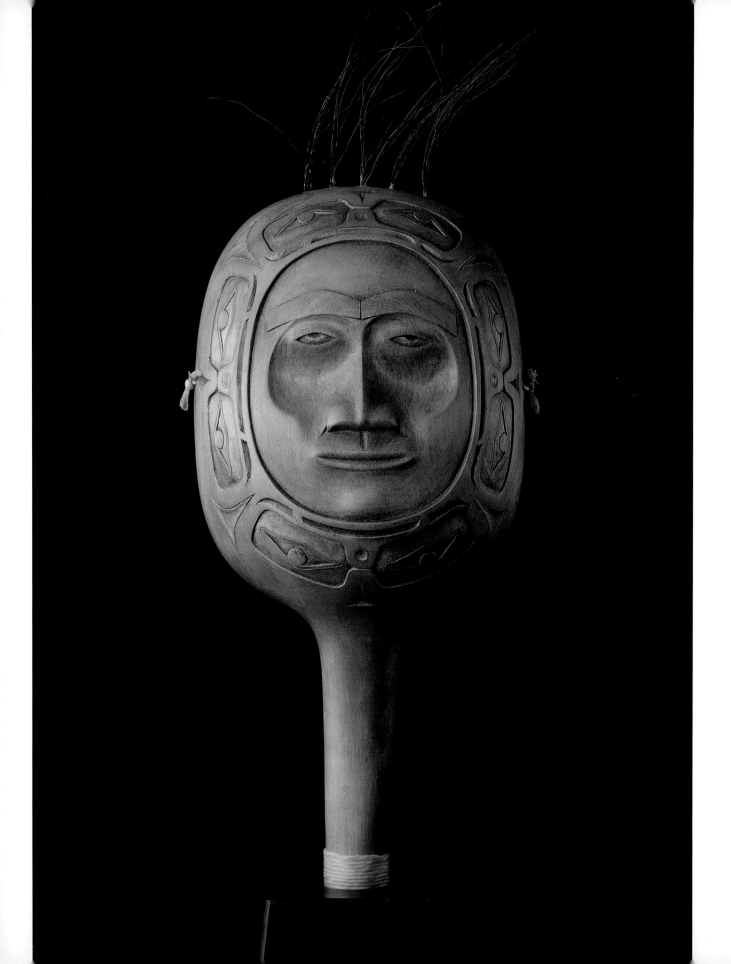

MY GRANDMOTHER

JOE DAVID: The design of this panel is based on the low-relief carved house posts or interior house panels made by the Coast Salish. The feather design and overall concept came from an Edward S. Curtis photograph of my grandmother, in which she is commonly referred to as a Nuu-chah-nulth (Nootka) or Clayoquot shaman woman. She was also featured in another Curtis photograph of a posed healing ceremony.

My grandmother was from the Ditidaht Nation near Nitinat Lake on Vancouver Island. I depicted her as pregnant with my father. When I was born, she prophesied that I would become an artist. She was known to have unique powers which have always been categorized as shamanism, but in reality were equally related to age, experience and family responsibility. The knowledge and power of the elders was earned over a lifetime.

Portrait of My Grandmother

Joe David
Clayoquot (Nuu-chah-nulth)
red cedar, abalone shell, paint
44½ × 19½ × 2½ inches

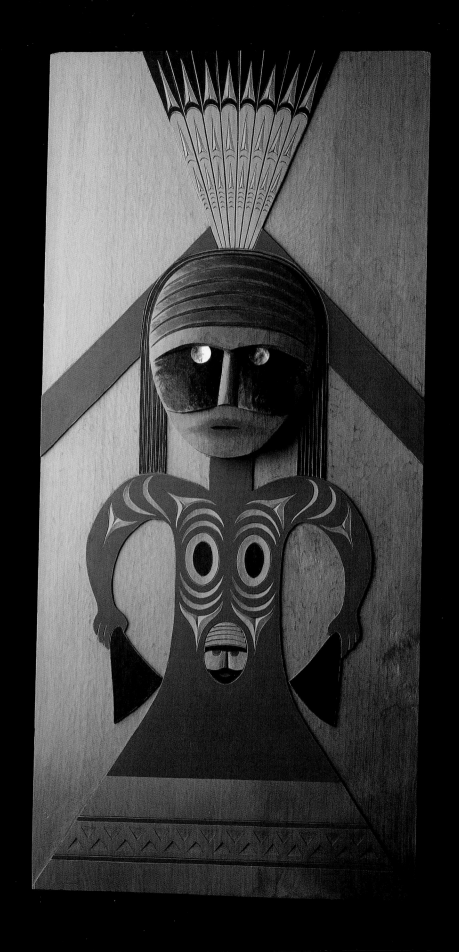

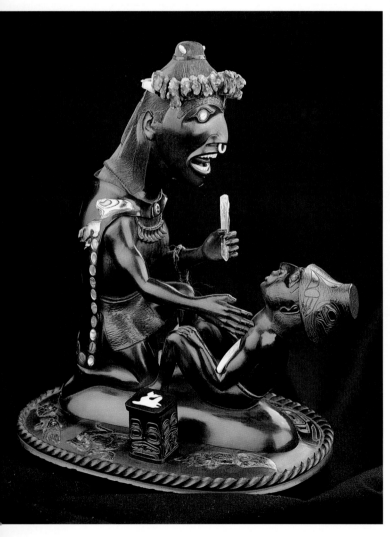

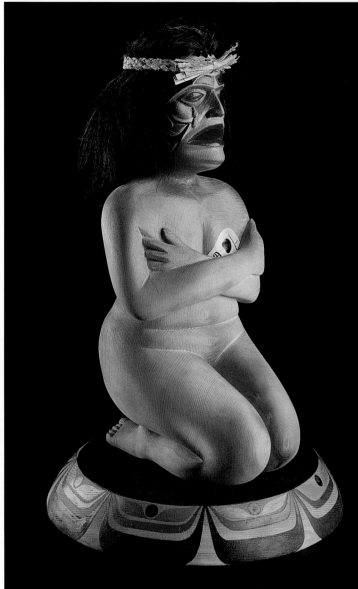

THE SPIRIT WORLD

THE SHAMAN

ALFRED COLLINSON: This sculpture shows a powerful shaman at a critical moment while performing a healing ritual on the son of a chief. The shaman is dressed in full regalia—cape, necklace, headpiece—and he has two boxes bearing Killerwhale crests to carry his implements and amulets. The inlays on the boxes announce the wealth and prestige of the shaman, who has earned the right to use these materials. Artistically, these same materials also add to the visual impact and drama of the moment.

Shaman Healing a Patient
on facing page, left

Alfred Collinson
Haida
argillite°, elk horn, whalebone, abalone shell, ivory
9½ × 7½ × 10 inches

° see note about argillite on page 84

WOMAN IN MOURNING FOR HER DEAD HUSBAND

MARVEN TALLIO: This piece tells the story of a young woman who is in mourning for her dead husband. She sits by his grave for four years before deciding to tunnel into the grave to be close to him. During the time that follows, she becomes pregnant by her dead husband. She proudly returns to her village with her newly born child wrapped in a blanket. When the woman's mother opens the blanket, there is only a skeleton of a dead child. She throws the bundle away, and the mother, grievously hurt, returns to her husband's grave and is never seen again.

Woman in Mourning
on facing page, right

Marven Tallio
Nuxalk
red cedar, cedar bark, horsehair, paint
17 × 11 × 11 inches

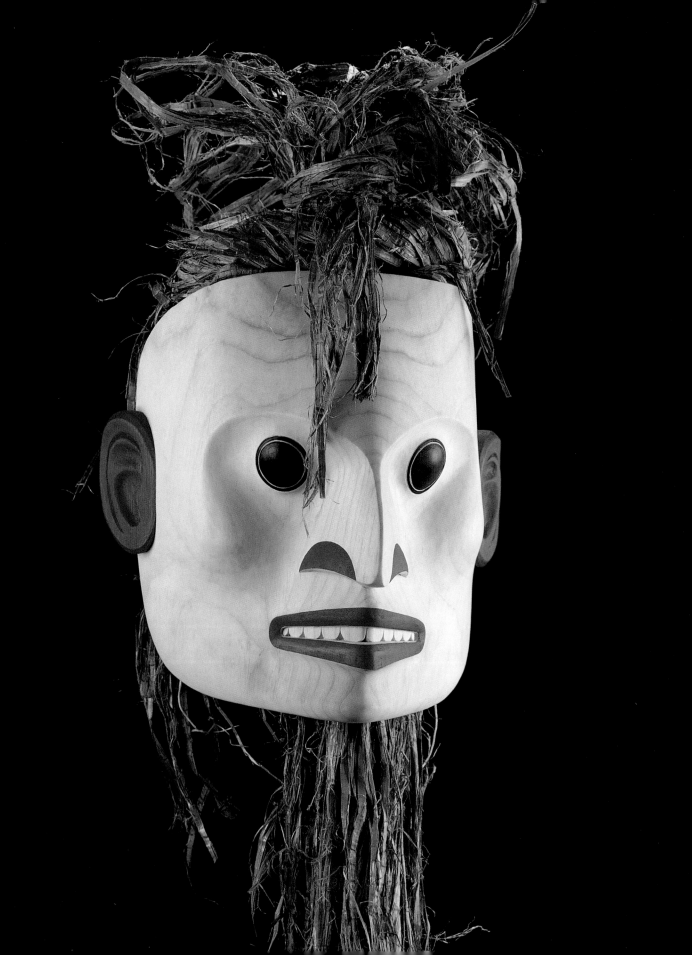

OTTER SHAMAN

JOE DAVID: I have spent a lot of time in sweat-lodges, working with vision prayers and with different people from different tribal and personal backgrounds, and we often find ourselves in corners not knowing how to proceed. I find the unknown to be interesting. There is great value in mystery. Historically, many things were simply not talked about. It was not that they were necessarily secret but there was an understanding that you had earned the knowledge. It was mutually assumed by those who shared the experience that the others had reached the same level of awareness.

When I was young, I was away from my family and the village, and when I returned in the early 1970s, I knew that they knew that I had already achieved a point of cultural interest and understanding. I paid attention, I learned things and I was interested.

Once, when I was at Nitinat Lake in central Vancouver Island, there was a group of otters swimming about 50 yards away. There was also a group of people in the same vicinity, and they were loud and aggressive. I was perched very quietly on a log set back from the water. An otter dove and resurfaced right in front of me and came ashore. A second later, by smell or by some small movement, it knew that I was there. There was a moment when our eyes met and a communication was made. It knew that it had nothing to fear from me, and you could see the muscles relax and the adjustment to knowing that I was not a threat. It then moved quietly past me.

Otter Shaman

Joe David
Clayoquot (Nuu-chah-nulth)
alder, cedar bark, paint
12 × 9 × 6½ inches

POOQ-OOBS

TSA-QWA-SUPP (ART THOMPSON): This figure is one of my interpretations of a legend about the whaling traditions of our people. The whalers were physically and mentally well prepared for their task, but sometimes they would be lost to the sea.

This legendary figure is about a whaling expedition where one of the whalers is lost overboard. The priority of the other members of the crew is to continue the hunt.

After an extended period in the water, the lost whaler's body would sometimes wash up onto a beach, then transform into another state of life. With his hair still tied back in the whaler's tradition, lacking eyes, his skin white and wrinkled, he then becomes known as Pooq-oobs. His remaining life is spent as a shy recluse, foraging on the beaches and eating seafood or whatever he can find.

Pooq-oobs and Whale

Tsa-qwa-supp (Art Thompson)
Ditidaht (Nuu-chah-nulth)
red cedar, horsehair, abalone shell, paint, rope
60 × 25 × 19 inches

THE SPIRIT WORLD

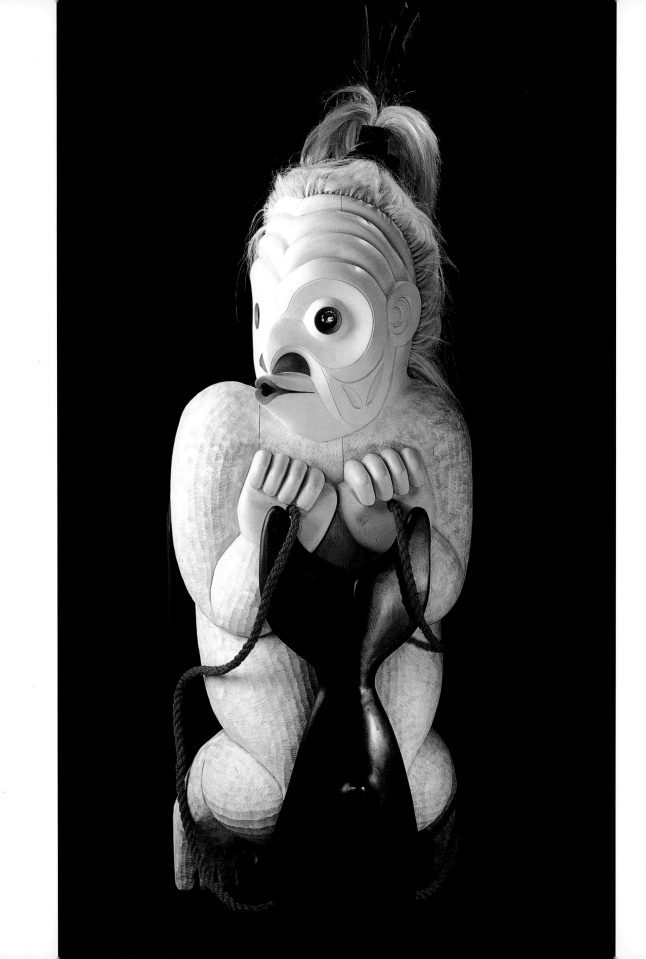

WAYNE ALFRED
(born 1958)

Wayne Alfred began carving with Beau Dick, assisting him on numerous commissions, particularly for Expo 86 in Vancouver. His work has been featured in major exhibitions, including "Down from the Shimmering Sky" at the Vancouver Art Gallery and "Native Vision" at the Seattle Art Museum. He was one of eight carvers chosen to create the new ceremonial bighouse at Alert Bay.

DEMPSEY BOB
(born 1948)

Dempsey Bob studied with Freda Diesing and attended the Gitanmaax School of Northwest Coast Art. His work is in the collections of the Canadian Museum of Civilization, the University of British Columbia Museum of Anthropology, the Smithsonian Institution, the National Museum of Ethnology in Japan, the Museum of Ethnology in Germany, Canada House in London, the Royal British Columbia Museum and Vancouver International Airport. A major innovator in the Tahltan-Tlingit style, he is widely exhibited and also has poles in England, Alaska and the United States.

STEPHEN BRUCE
(born 1968)

Steven Bruce began carving with Wayne Alfred and has worked on several monumental commissions, including an 18-foot pole for the Mitsui Corporation in Tokyo. He was head carver for the creation of a Kwakwaka'wakw village, including several totem poles, at Dolfinarium Theme Park in Harderwijk, Holland. He was one of eight carvers chosen to create the new ceremonial bighouse at Alert Bay.

DELORES CHURCHILL
(born 1929)

Delores Churchill belongs to a family of weavers, including her mother, Selina Peratrovich, and her three daughters— Holly and April Churchill and Evelyn Vanderhoop. She has been instrumental in maintaining and teaching weaving traditions. Her work has been displayed in many shows featuring weaving artists and ceremonial regalia, including "Crossroads of Continents" at the Burke Museum in Seattle and other galleries.

ALFRED COLLINSON
(born 1951)

Both of Alfred Collinson's grandfathers, Lewis Collinson and Arthur Moody, were prominent argillite carvers. He began carving in 1960 and was one of the founders of the modern period of argillite carving. His most recent theme is the large-scale narrative depiction of myths, using various materials for complex inlays and detailing.

JOE DAVID
(born 1946)

Joe David was one of the core group of artists that led the resurgence in Northwest Coast art and culture. Attending art school in Texas only increased his interest in the artistic traditions of his own people. He rapidly emerged as an important new artist and his reputation has continued to grow. In addition to releasing several important limited edition prints, he is highly regarded as a sculptor, and his work is in museums and private collections internationally.

REG DAVIDSON
(born 1954)

Reg Davidson worked with his brother Robert on several monumental projects, beginning with the 1969 totem pole for Massett, the first raised on Haida Gwaii in over one hundred years. He began carving on his own in 1972 and has produced a number of totem poles for public and private international commissions, as well as for Haida families. His work has appeared in group exhibitions, and he has had several solo shows. He is also a renowned dancer.

ROBERT DAVIDSON, RAA, CC
(born 1946)

One of the most acclaimed artists on the Northwest Coast, Robert Davidson is noted for his innovative work in wood, bronze, graphics and jewellery. In 1993-94, the Vancouver Art Gallery and the Canadian Museum of Civilization presented a retrospective exhibition of his work. With photographer Ulli Steltzer, he published a book on his career, *Eagle Transforming: The Art of Robert Davidson*. He has received many major international commissions, and his work is in the collections of museums, corporations and individuals around the world.

SIMON DICK
(born 1951)

Simon Dick is a renowned dancer, and his distinctively contemporary work is influenced by his understanding of the demands of pieces meant for ceremonial use. His 9 x 18-metre Thunderbird, displayed at Expo 86 in Vancouver and Expo 88 in Brisbane, is in the Canadian Museum of Civilization. His work was in "Down from the Shimmering Sky" at the Vancouver Art Gallery.

FREDA DIESING
(born 1925)

Freda Diesing was a student in the first class at the Gitanmaax School of Northwest Coast Art in Hazelton, B.C. Many artists acknowledge her as an important teacher or influence. She has taken part in most of the major exhibitions of contemporary Northwest Coast art, including "The Legacy" at the Royal British Columbia Museum and "Down from the Shimmering Sky" at the Vancouver Art Gallery.

GERRY DUDOWARD
(1950-1998)

Gerry Dudoward's grandmother told him the myths of his people, and later, urban Native issues reinforced his interest and belief in Native values and traditions. His study of Tsimshian design in museum collections led to his interest in ceremonial rattles. He created many variations of chief's rattles and shaman's rattles, seeking with each one to deepen his level of understanding.

CHUCK HEIT (YA'YA)

Chuck Heit worked with artists who taught at the Gitanmaax School of Northwest Coast Art in Hazelton and later taught there himself. His major influence is his uncle, the master carver Walter Harris. Heit assisted him, Earl Muldoe and Ken Mowatt on totem pole commissions, as well as working on many of his own. He apprenticed with Robert Davidson for two years.

FRANCIS HORNE

Francis Horne began to carve in 1973 and is largely self-taught. He has produced numerous major totem poles for public, corporate and private international commissions. The city of Duncan, known as the "City of Totem Poles," has five of his poles. His elaborate masks and smaller works are limited in number, as his reputation for large-scale works keeps him busy.

RICHARD HUNT, CM, OBC
(born 1951)

In 1973, Richard Hunt became an apprentice carver to his father, Henry Hunt, at the Royal British Columbia Museum; a year later, he assumed the position of chief carver until he left in 1989 to concentrate on his own art. He has received numerous commissions for totem poles and ceremonial pieces, including Vancouver International Airport. His work has been featured in many exhibitions, including "The Legacy" at the Royal British Columbia Museum and "Down from the Shimmering Sky" at the Vancouver Art Gallery.

BILL KUHNLEY
(born 1967)

Bill Kuhnley grew up surrounded by carvings made by his parents, William and Josephine Kuhnley. He began carving at the age of thirteen and left school at sixteen to join his parents' cedar salvage business. He has been carving fulltime since 1991, including a period as a carver with the Duncan Heritage Centre on Vancouver Island and a four-year apprenticeship with Robert Davidson.

KEN McNEIL
(born 1961)

Ken McNeil apprenticed with his uncle Dempsey Bob and has assisted him on many of his monumental commissions as well as working on major private and corporate commissions of his own. With Stan Bevan, he carved a totem pole for Expo 92 in Seville and a house post for the First Nations House of Learning at the University of British Columbia in Vancouver. His work has been in many exhibitions, and he is leading artist of the new generation.

TIM PAUL
(born 1950)

Tim Paul began carving in 1973 under the direction of Ben Andrews and later John Livingston at the Arts of the Raven Studio in Victoria. He worked as assistant carver to Richard Hunt at the Royal

British Columbia Museum, later becoming senior carver. He has produced many totem poles for international sites and uses his extensive knowledge of myth and design to create innovative works.

SUSAN POINT
(born 1952)

Susan Point, one of the most innovative artists of her generation, began working as an artist in the early 1980s. Her love of experiment led her to adapt Coast Salish imagery to nontraditional materials, including glass, with great critical success. She has produced numerous large-scale pieces for public spaces, including Vancouver International Airport, the Victoria Convention Centre and the Sprint Canada Building in Toronto.

VICTOR REECE
(born 1946)

Victor Reece is a member of the Wolf Clan of the Tsimshian Nation, and his hereditary name is Whe'X Hue ("big sky"). In addition to being an artist, he is known as a storyteller and educator, and has been employed in those capacities by the Vancouver School Board. His work has appeared in many group exhibitions, and he assisted in the design and construction of a traditional Tsimshian longhouse for the Canadian Museum of Civilization.

ISABEL RORICK
(born 1955)

Isabel Rorick comes from a long line of weavers, including her great-grandmother Isabella Edenshaw; her grandmother, Selina Peratrovich; her mother, Primrose Adams, and her aunt Delores Churchill. Rorick's work was included in "Topographies: Aspects of Recent British Columbia Art" at the Vancouver Art Gallery and in "Native Vision" at the Seattle Art Museum.

LARRY ROSSO
(born 1944)

Larry Rosso apprenticed with Lloyd Wadhams and later with Doug Cranmer. He received the name Sisakolas ("to travel to and from a potlatch by canoe") at a potlatch held by Amos Dawson. From 1987 to 1991, he assisted Robert Davidson. Rosso is noted for his bowls and boxes, particularly for those using the bentwood technique.

RON RUSS
(born 1953)

Ron Russ is largely self-taught. He has read all the books on Haida art and culture and studied old pieces by the master artists. He carves primarily in argillite, although he also works in precious metals and wood. His work is in the Museum of Northern British Columbia, the Canadian Museum of Civilization and the University of British Columbia Museum of Anthropology.

CHERYL SAMUEL
(born 1944)

Cheryl Samuel has been largely responsible for the revival of the Chilkat and Ravenstail weaving traditions on the Northwest Coast. Her research about and weaving within the Chilkat tradition and the older robe technique now known as Ravenstail led to her writing two books, *The Chilkat Dancing Blanket* and *The Raven's Tail: Northern Geometric Style Weaving*.

LIONEL SAMUELS
(born 1964)

Lionel Samuels is the grandson of Andrew Brown, a prolific and renowned Haida argillite carver. Samuels began carving argillite under the direction of Claude Davidson (father of artists Robert and Reg Davidson) and later worked with George Yeltatzie to learn how to carve precious metals for jewellery. He has been carving full-time since the age of twenty.

PRESTON SINGLETARY
(born 1963)

Preston Singletary, who studied at the Pilchuk Studio in Stanwood, Washington, is the first Northwest Coast artist to be trained entirely in the art of glass. His work based on traditional Northwest Coast objects translated into art glass has given him a new direction and purpose, as well as the opportunity to pay homage to his family and ancestors.

DON SVANVIK
(born 1958)

Don Svanvik's early teachers included Beau Dick and Sam Johnson. In addition to carving ceremonial pieces, he worked on the re-creation of a Kwakwaka'wakw village for the Dolfinarium

Theme Park in Harderwijk, Holland. He was one of eight carvers who worked on the new ceremonial bighouse in Alert Bay.

NORMAN TAIT

(born 1941)

Norman Tait learned carving and oral traditions from Nisga'a elders, and also studied Nisga'a artworks in museums. He was one of the first contemporary artists to be honoured with a solo exhibition at the University of British Columbia Museum of Anthropology. His commissions include poles for the Field Museum, the British Royal family, the National Museum of Ethnology in Japan, the University of British Columbia Museum of Anthropology and two major sculptures for the Vancouver Stock Exchange.

GLENN TALLIO

Glenn Tallio learned to carve at a very young age from his father. Because of his deep understanding of Nuxalk traditions, many of his pieces are commissioned for ceremonial purposes. His work is in many museums, including the Canadian Museum of Civilization and the University of British Columbia Museum of Anthropology. He oversaw the creation of the Nuxalk longhouse in the Canadian Museum of Civilization.

MARVEN TALLIO

(born 1966)

Marven Tallio began carving as a boy under the direction of his father, Glenn Tallio, and assisted him with the construction of the Nuxalk longhouse for the Canadian Museum of Civilization. He was commissioned to carve a four-way-split transformation mask for installation inside the longhouse. He works in both wood and precious metals, and has produced numerous ceremonial commissions.

TSA-QWA-SUPP (ART THOMPSON)

(born 1948)

Tsa-qwa-supp studied at Camosun College in Victoria and at the Vancouver School of Art. He creates highly accomplished works in wood, precious metals and graphics. His large-scale works include a totem pole for the Victoria Convention Centre and a private commission donated to Stanford University to honour the twenty-fifth anniversary of the first aboriginal graduate. In 1990, he assisted Tim Paul with a 50-foot totem pole for the Commonwealth Games in Auckland, New Zealand.

LUCINDA TURNER

(born 1958)

Lucinda Turner began carving under the direction of Norman Tait in 1991. They have collaborated on several major commissions, including two for the Vancouver Stock Exchange, and several other pieces. Turner also works on her own in a variety of media.

EVELYN VANDERHOOP

Evelyn Vanderhoop studied weaving with Cheryl Samuel and Delores Churchill. She is also a successful watercolour artist, and one of her watercolours was chosen as a reference for a United States postage stamp commemorating Native American dance.

CHRISTIAN WHITE

(born 1962)

Christian White learned to carve argillite at the age of fourteen from his father, Morris White. His style is based on the narrative depiction of a specific moment within a myth or story. He has a deep understanding of the historic styles of argillite carving and often uses inlays to enhance details and to add to the visual presence of his sculptures.

LYLE WILSON

(born 1955)

Lyle Wilson studied at Emily Carr College of Art and Design and the University of British Columbia. He is the artist in residence at the University of British Columbia Museum of Anthropology (MOA). A solo exhibition of his work opened at the MOA in 1989 and travelled to eight other venues. He has produced major commissions in Vancouver for the First Nations House of Learning, the Canadian Institute for the Blind and the B.C. Sports Hall of Fame, as well as for the Canadian Consulate in Osaka, Japan.